U0040210

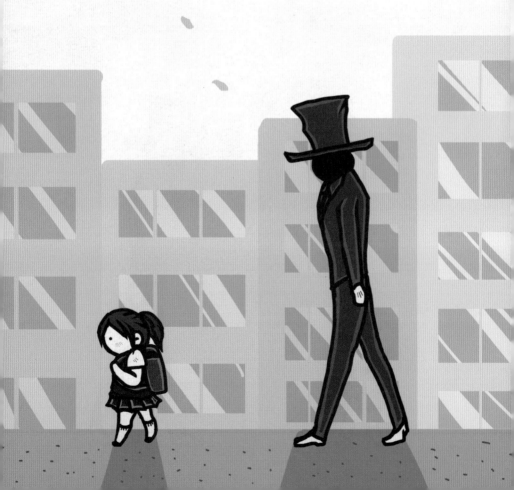

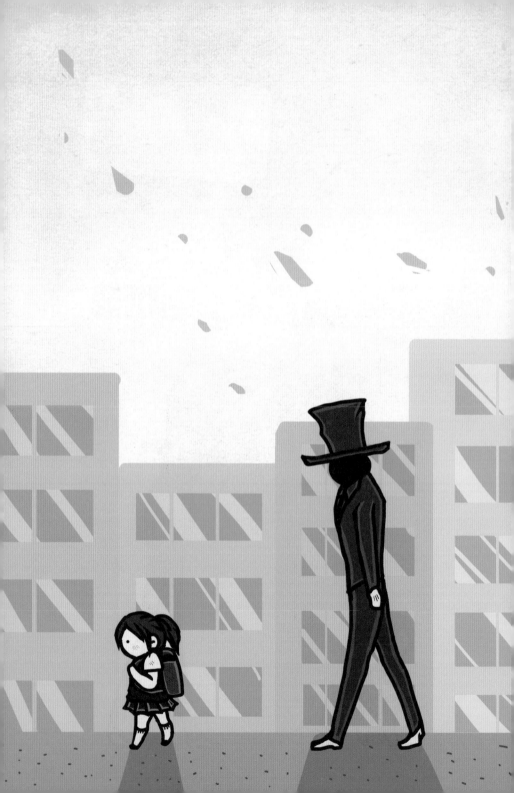

她與
黑色的守護者

The Girl and Her Black Guardian

寶總監 Director Bao ／著

這本書是寶總監心願屋系列的第二集,希望大家會喜歡,那些失去心愛寵物的人們,請不要忘記,死亡並不是結束,他們永遠不會離開你,只是你看不到他們而已,請繼續向前走,幫助更多沒有家的動物,最終你們必定會以另一種方式重逢。

我要感謝我兩條秘書,他們一條會說英文,一條會說日文,我們已經認識了13年,他們幫我處理了很多雜事,我要在這裡感謝讚美他們!

This is Director Bao's house of wishes II, I hope you guys like it. For those who have lost your beloved babies, please don't consider it as an end. They never leave you though you cannot see them. So move on and give your help to more animals in need. You can look forward to a reunion.

I wanna say thank you to my two assistants. One speaks English and the other speaks Japanese. We've known each other for 13 years. They've been helping me a lot. I would like to give my appreciation to them!

寶總監與泥褲 Director Bao and Akita Niku CEO

太了解我老闆了,不把人弄哭他是不會罷休的(咦),狗狗真的是人類一輩子的好朋友,就算哪天當小天使去了,他也會默默守護在你身旁。有了狗狗之後會發現,狗狗能教給人類的事情其實很多!

I know my boss very well. She won't be satisfied unless you tear up from reading her book. Doggies are our friends forever. Even if they leave this world and become little angles, they still stay by our side with no regrets. After having Dowu, I realized that I have learned lots of stuffs from him!

英語系秘書RITA與她的狗豆油 Rita and Dowu

每次老闆出新書總是憂喜參半,憂的是不知道又要準備多少面紙才夠,每次要打開書之前都要做好心理建設(寶老闆表示憤怒)。狗一直以來都是我最忠實的好友,有隻Kiki在我身邊15年,3年前的冬天他生病了,但不可思議的是他選了一個全家人都在家,能陪著他走完人生最後一段路的時間離開,我想很多事都自有安排,就如同在那段時間剛好念到的存在主義:生命體總有一天會消失,但是他只是轉換成不同形式,但依然存在!就如同彩虹橋所說,狗兒都會在彩虹橋另一端永遠陪伴著我們。

I always feel happy but sad whenever a new book is released. I feel sad not knowing how much tissue paper would be used during the reading; you'd better be prepared before reading (Boss got mad when we said this). One faithful doggie named Kiki had been my good friend for 15 years. During the winter three years ago, he got sick and left us. It was kind of unbelievable that he chose to leave when everyone of my family was at home and stayed there to accompany him before laying into grave. I think many things are destined, just like the Existentialism saying the beings may disappear, but they actually exist after transformation into other forms! There is the rainbow bridge and our doggies will stay on the other side to wait for us.

日語系秘書MYRA與她的狗KIKI Myra and Kiki

第一章
寶總監心願屋

Chapter 1
Director Bao's house of wishes

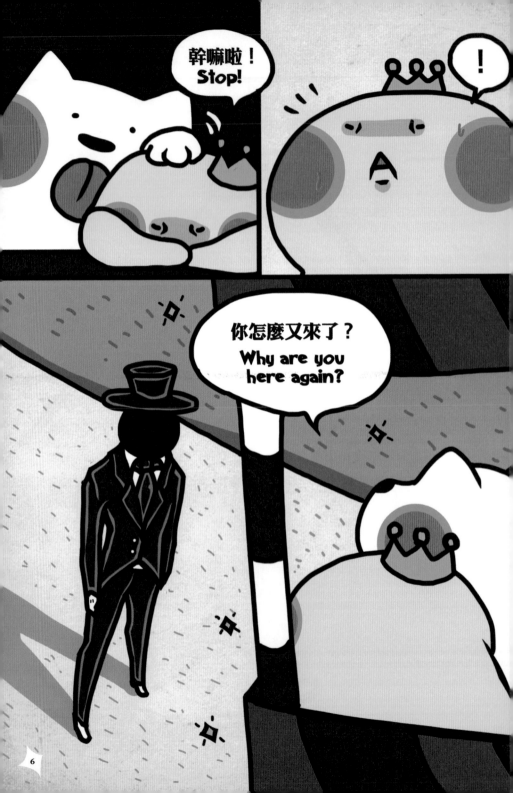

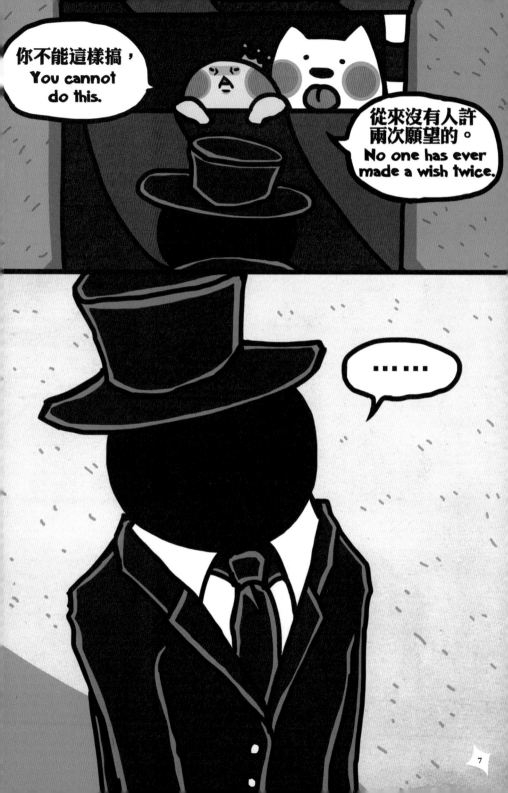

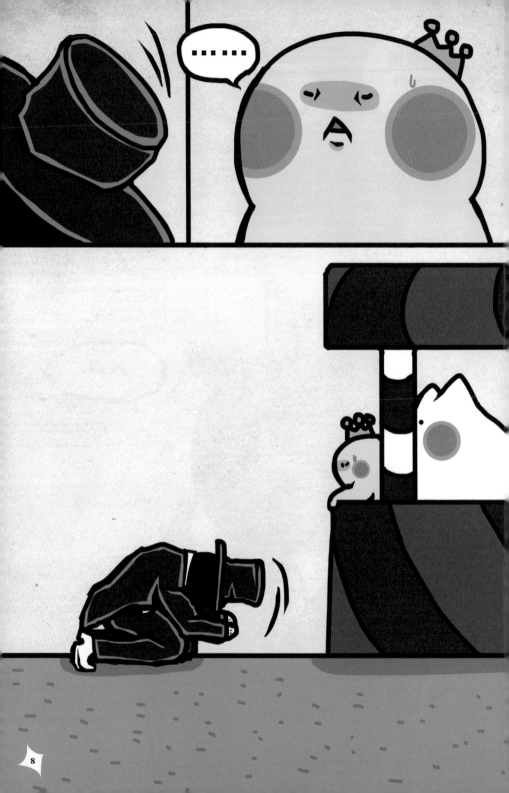

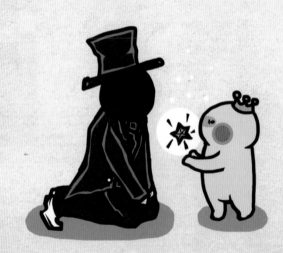

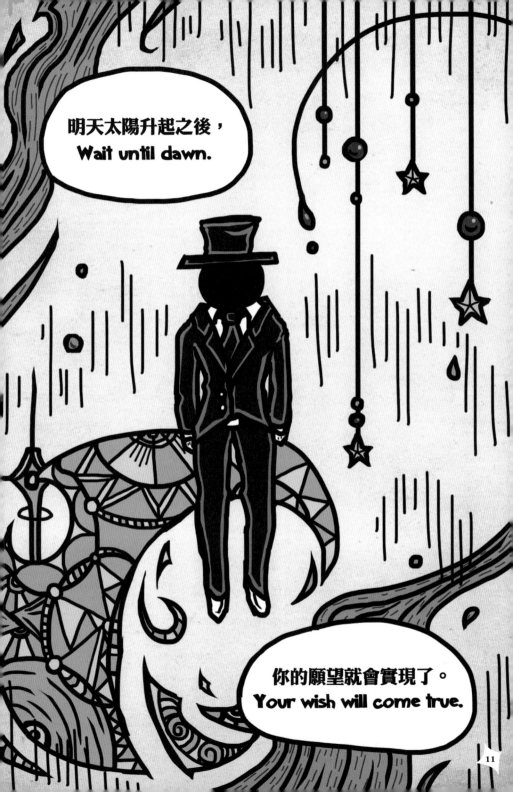

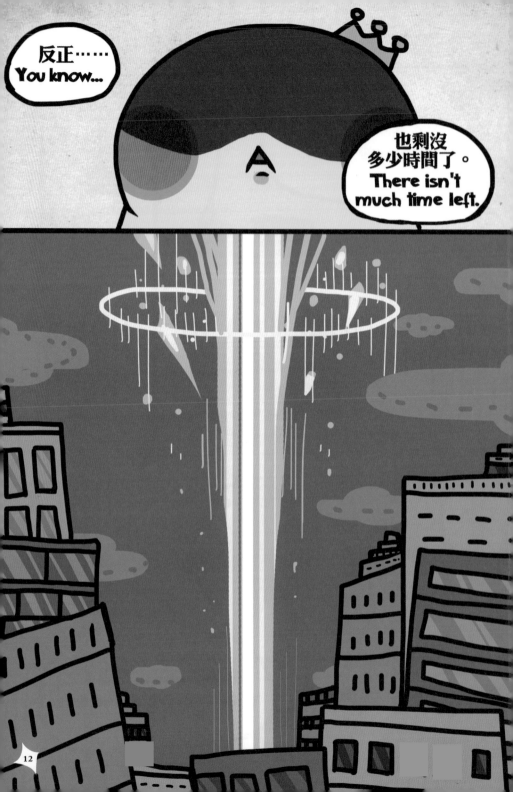

希望他們都能得到永遠的幸福。
May their happiness last eternally.

第二章
女孩與穿黑西裝的男人
Chapter 2
The girl and the man in black suit.

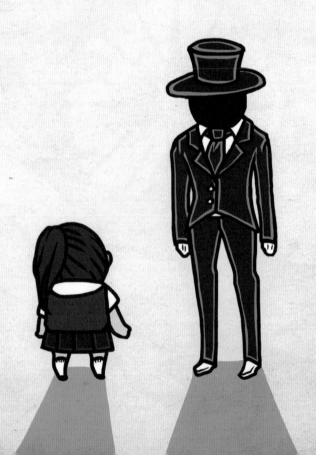

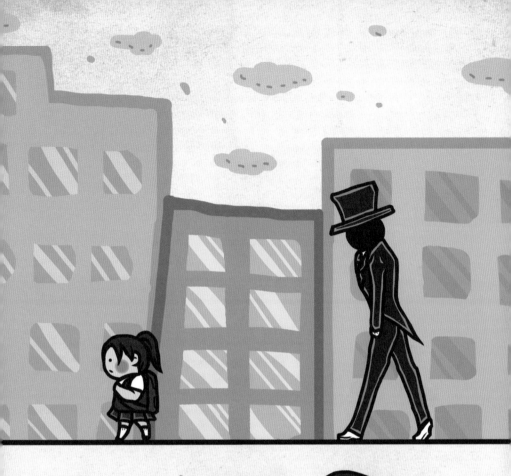

這個男人已經跟在我身邊很久了。
This guy had been here
for a long time.

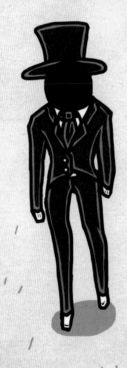

我國中時第一次看見他，
是在我房間裡。

First time we met,
it was in my room,
I was a junior
high school student.

他就那樣靜靜的
坐在角落。

He was sitting
in the corner
quietly.

他看起來
像是個紳士。
He looked like
a gentleman.

穿著黑西裝，
戴著白手套，
In black suit
with white gloves,

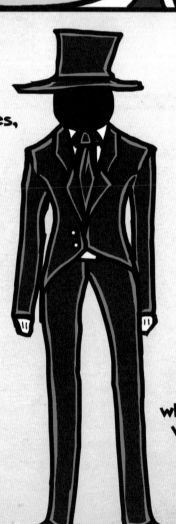

穿著白皮鞋，
身材修長。
white leather shoes,
very tall and slim.

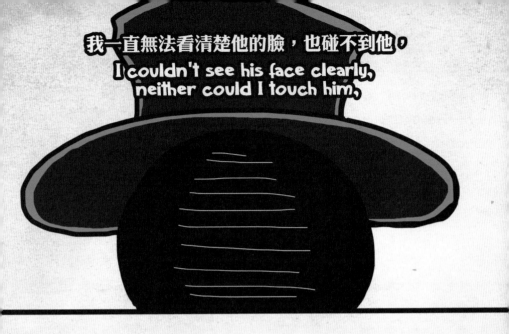

我一直無法看清楚他的臉，也碰不到他，
I couldn't see his face clearly,
neither could I touch him,

奇怪的是，我並不會感到害怕。
Untypical of me, I wasn't scared.

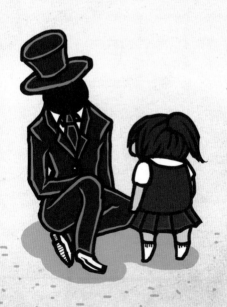

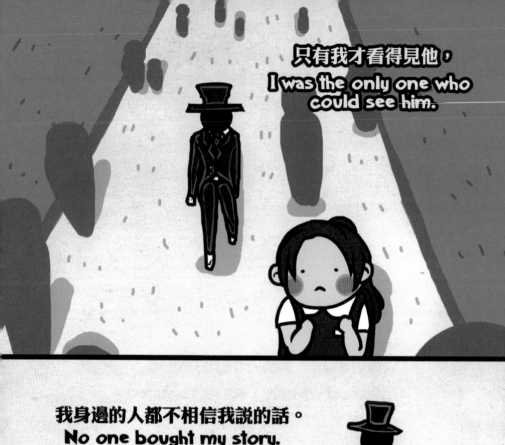

只有我才看得見他，
I was the only one who could see him.

我身邊的人都不相信我說的話。
No one bought my story.

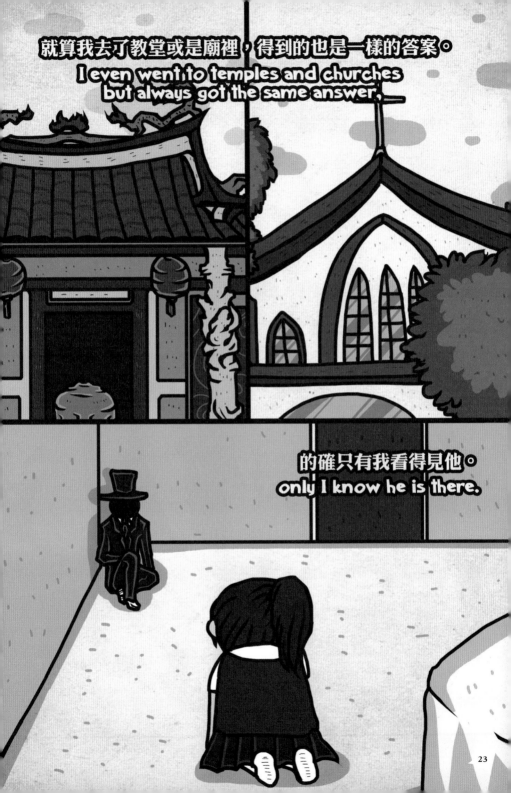

就算我去了教堂或是廟裡，得到的也是一樣的答案。
I even went to temples and churches but always got the same answer,

的確只有我看得見他。
only I know he is there.

23

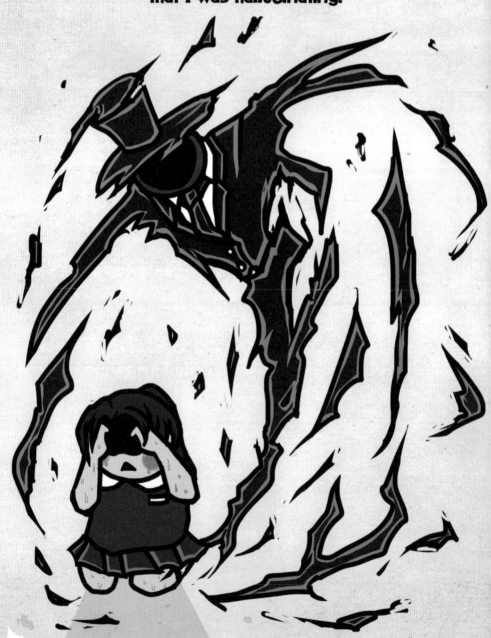

我曾經一度以為我得了精神病，
覺得這個男人是我幻想出來的。

I thought that I had become insane,
that I was hallucinating.

他總是靜靜的待在我身邊，並不會打擾到我。
He stayed by my side all the time, silently,
and never interrupted me.

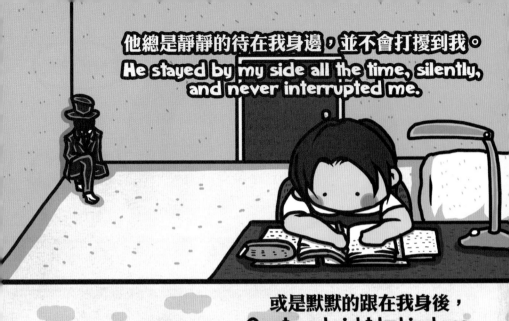

或是默默的跟在我身後，
Or stayed right behind me.

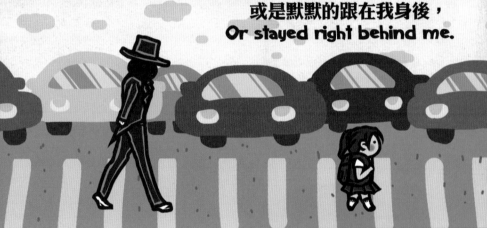

慢慢的，我習慣了他的存在。
Then, I found myself
getting used to it.

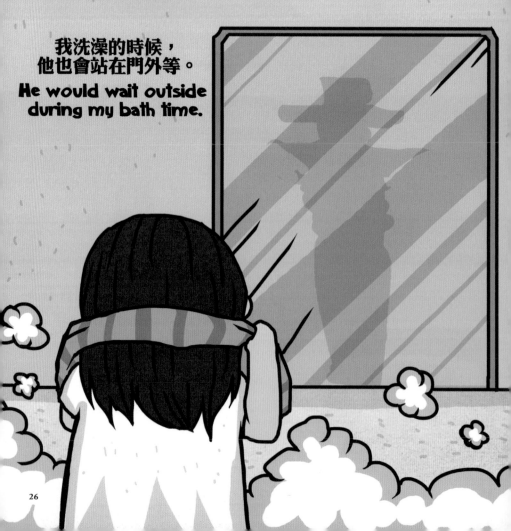

我洗澡的時候，
他也會站在門外等。
He would wait outside
during my bath time.

他總是跟我形影不離，尤其是我悲傷寂寞的時候。

He was just like my shadow, never going away, especially when I was sad and lonely.

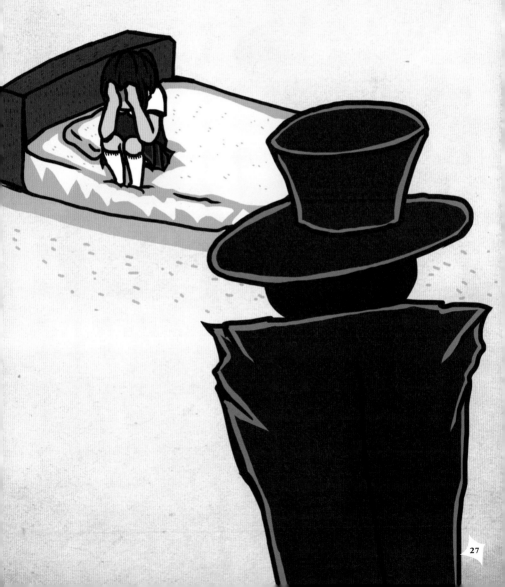

他會坐到我身旁像是在安慰我。

When he sat right next to me,
it was like he was trying to cheer me up.

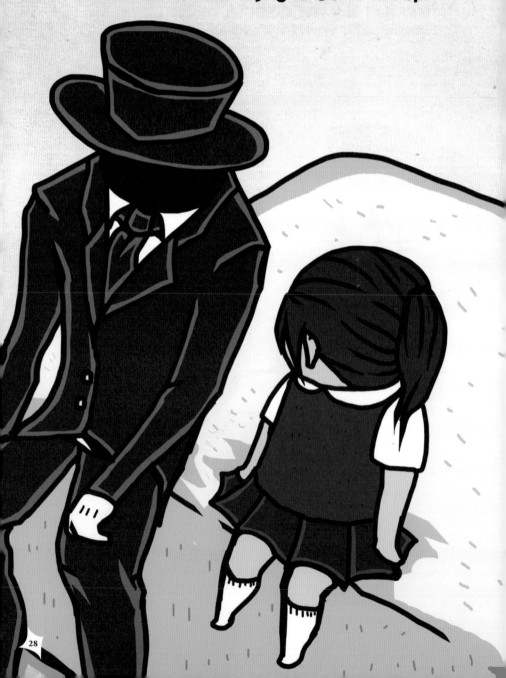

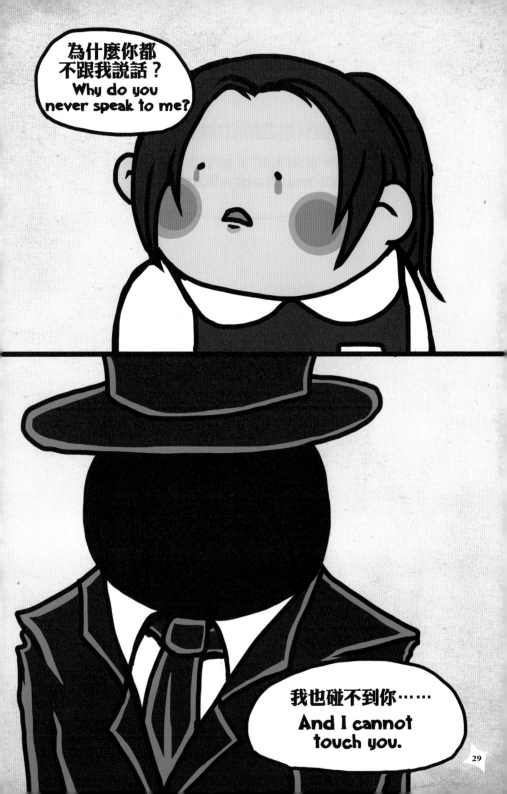

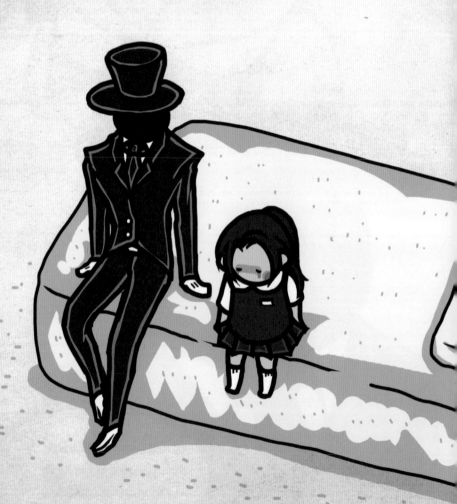

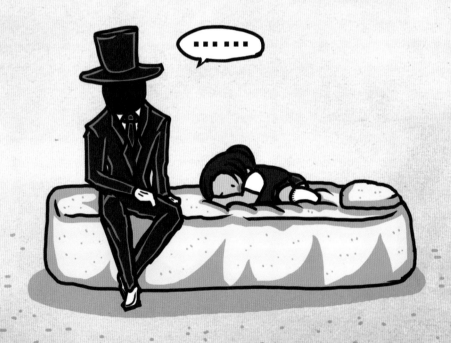

時間過得很快。
Time flied.

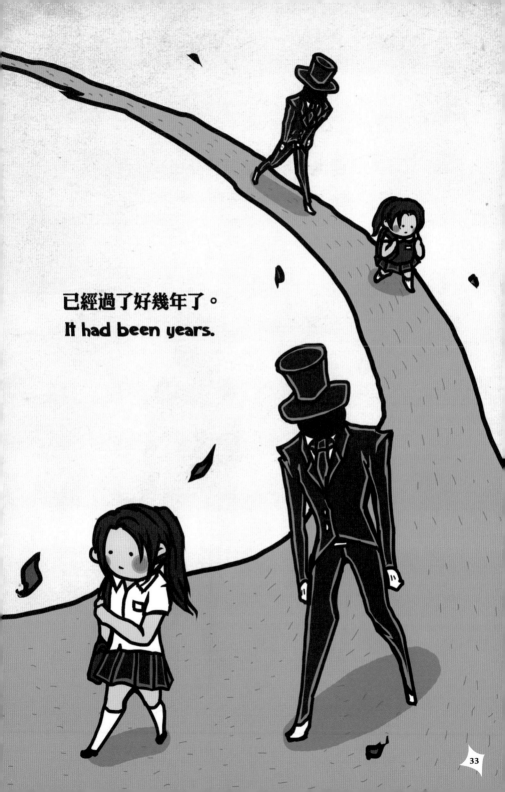

已經過了好幾年了。
It had been years.

他從來不曾離開我身邊。
He's always by my side.

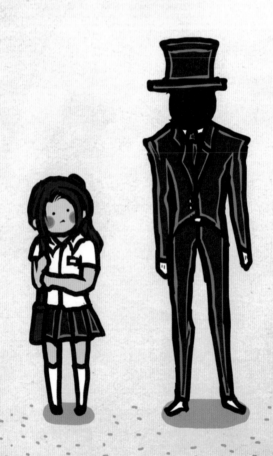

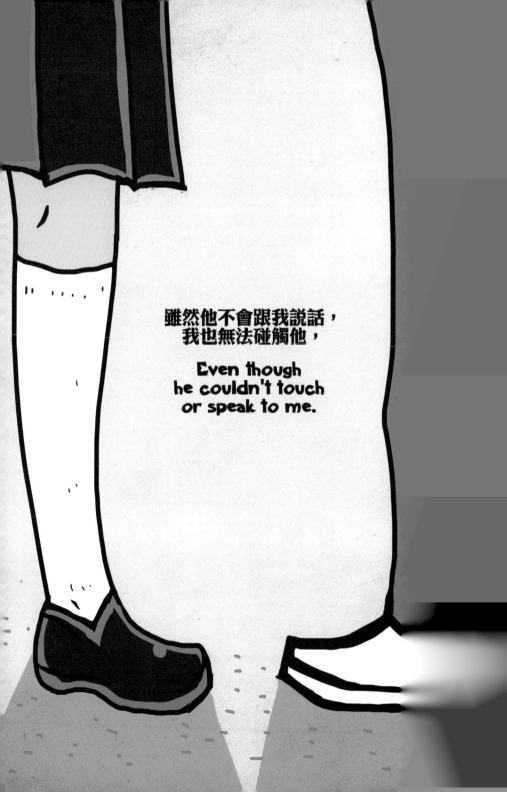

但我已經習慣有他陪伴的生活了。

I found myself deeply
connected to him.

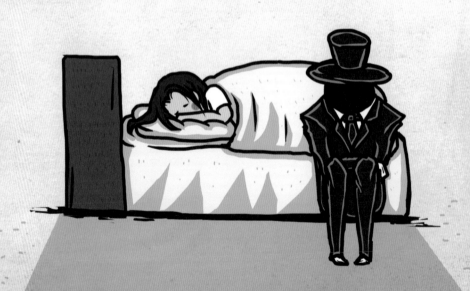

第三章
從未離開

Chapter 3
Never too far away

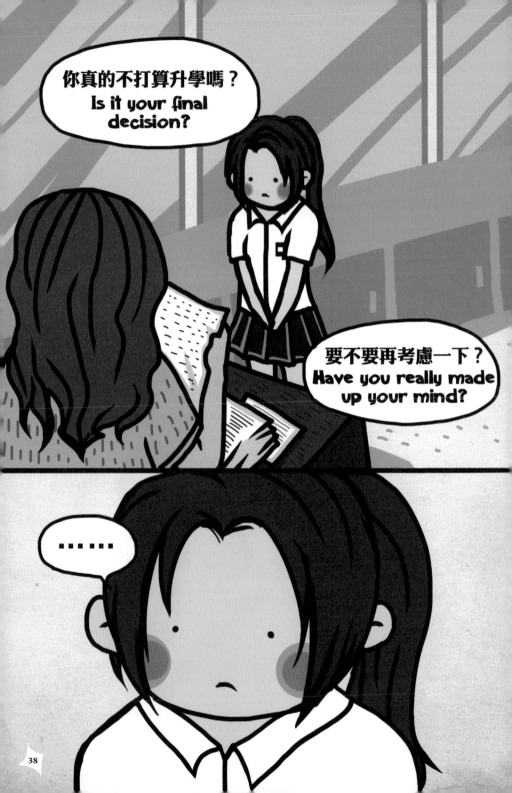

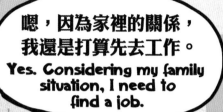

嗯，因為家裡的關係，
我還是打算先去工作。
Yes. Considering my family
situation, I need to
find a job.

這樣啊，
真是可惜……
Well, it's a pity.

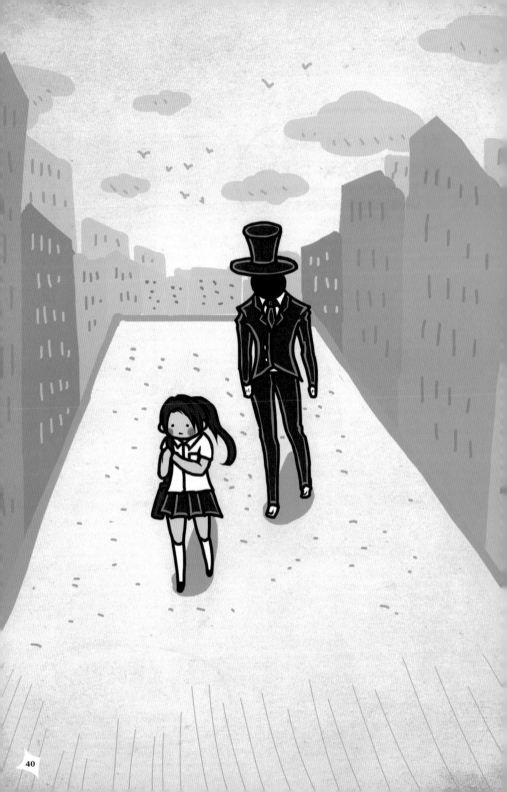

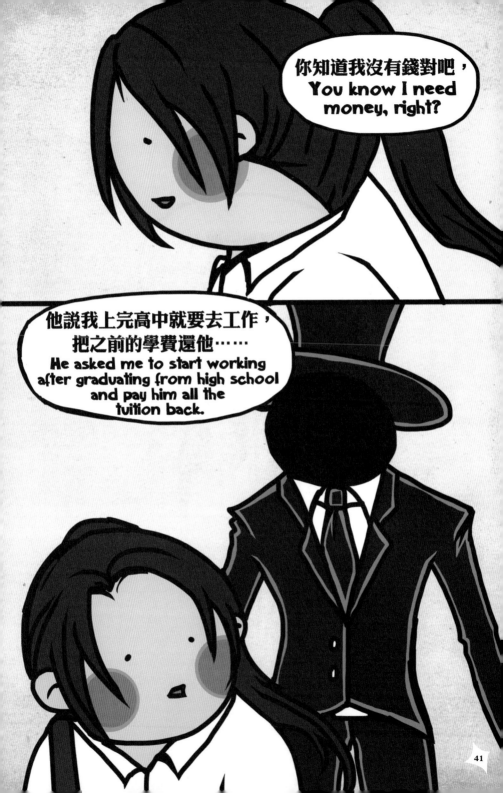

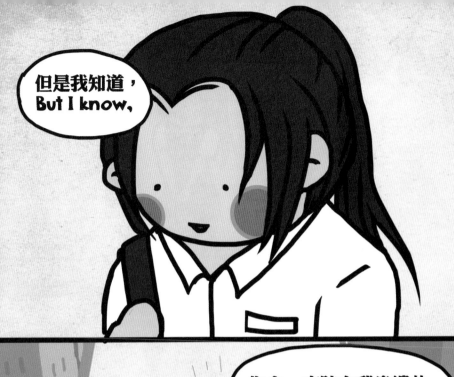

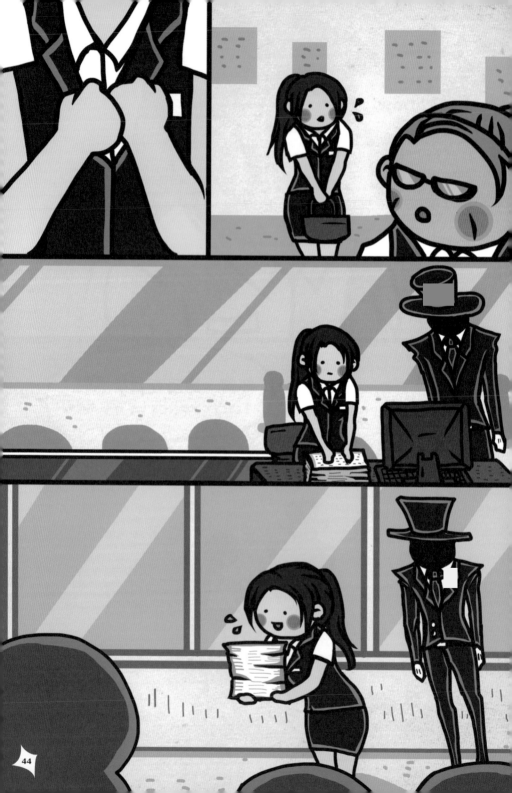

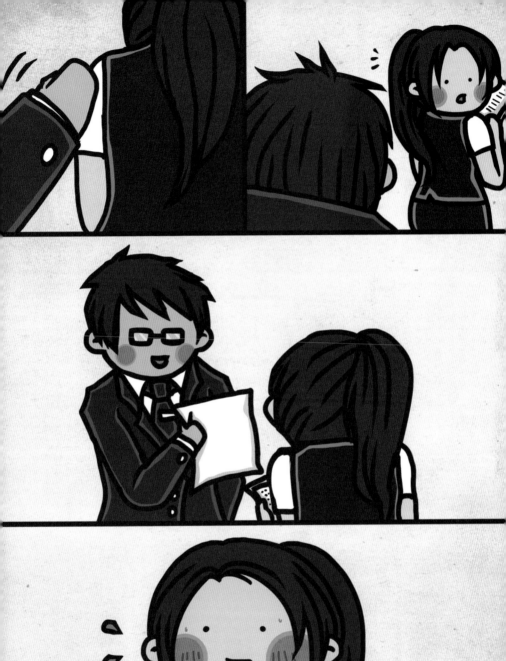

今天下班要一起去吃個飯嗎？
Do you wanna have
dinner after work?

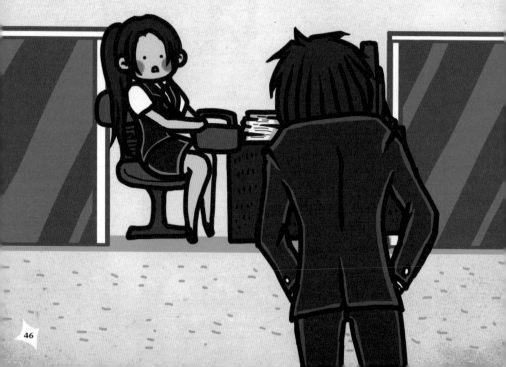

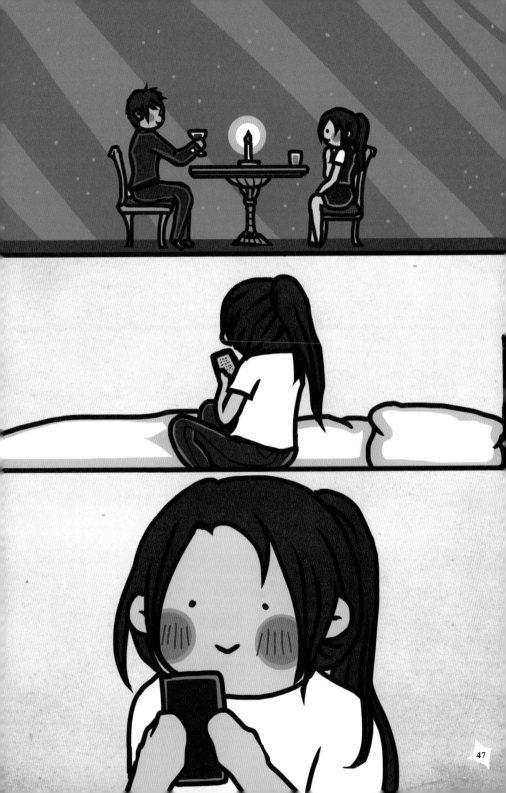

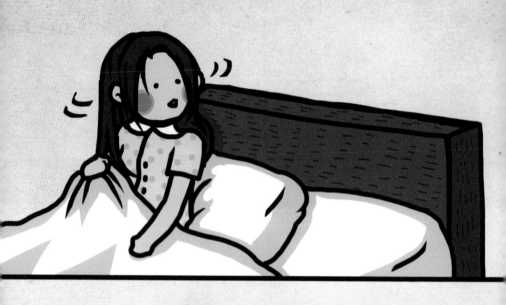

最近……
He...

他越來越少出現了……
stopped showing up as
often as he used to.

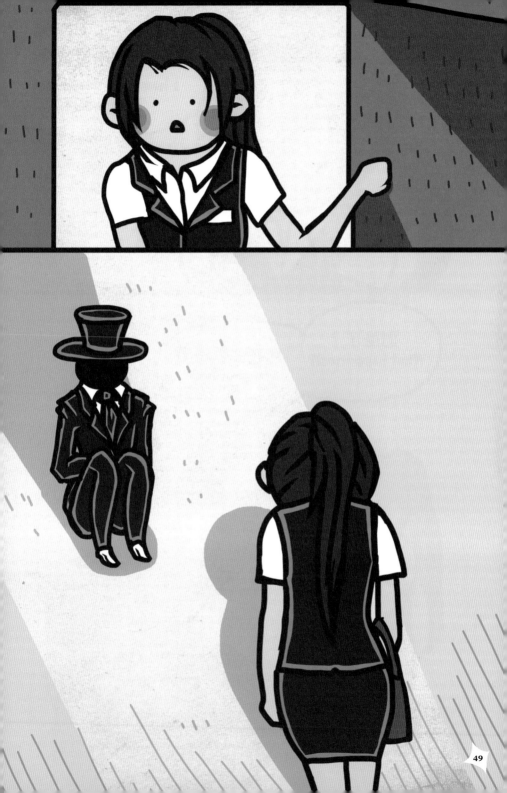

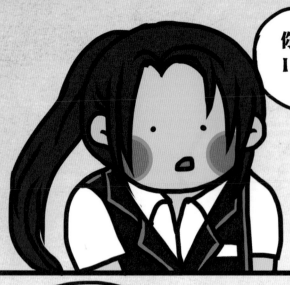

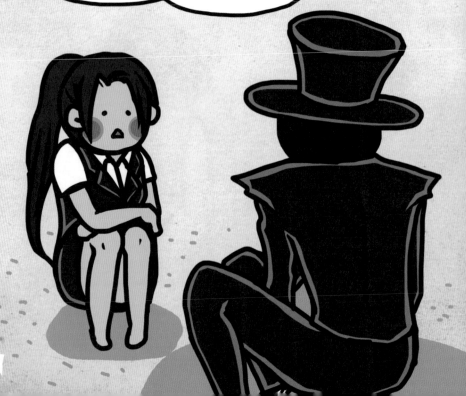

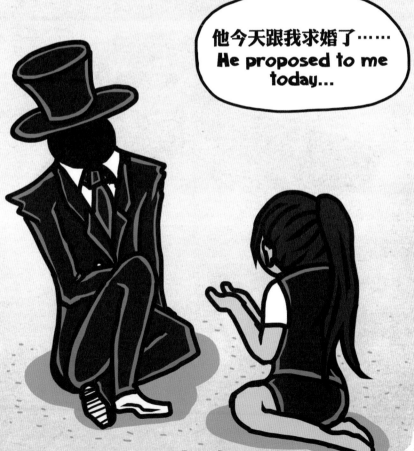

52

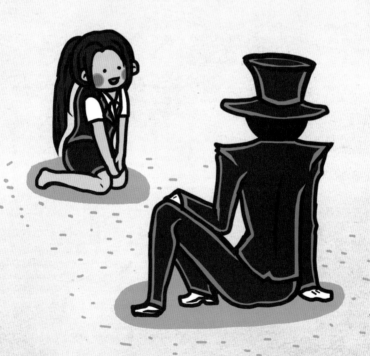

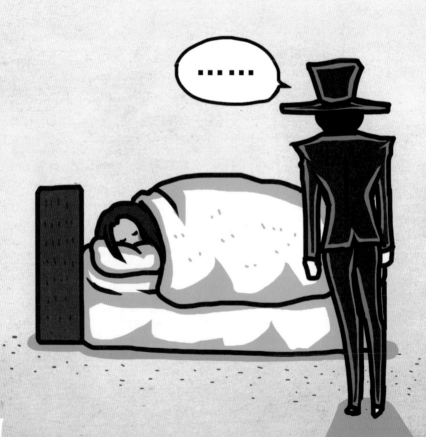

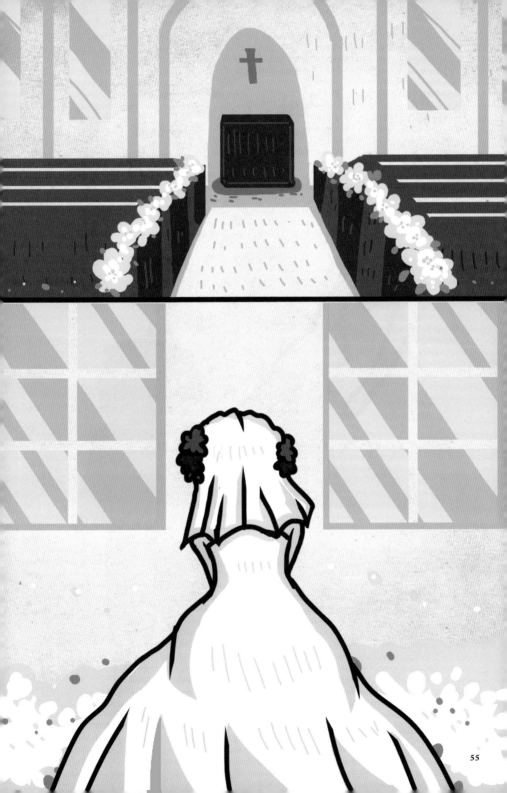

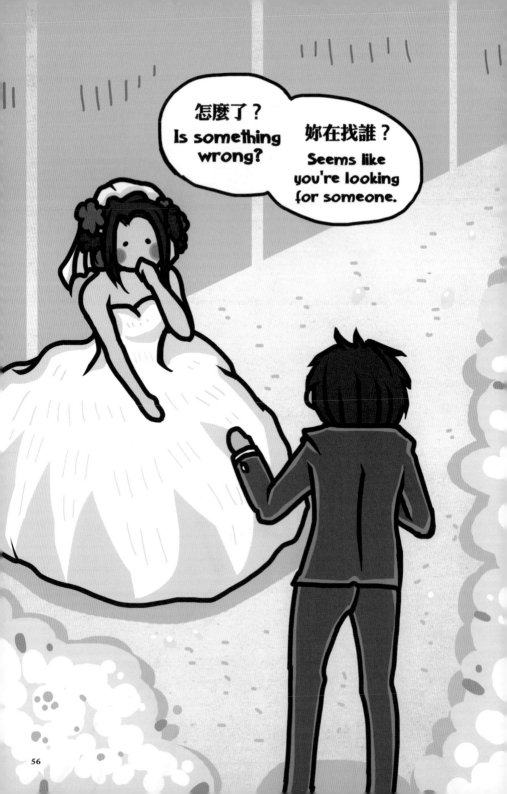

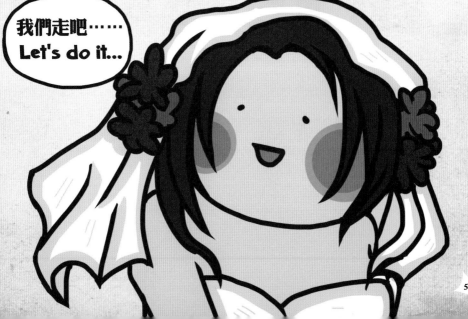

從我結婚的那天起，男人再也沒出現過了。
After my wedding, the man was gone.

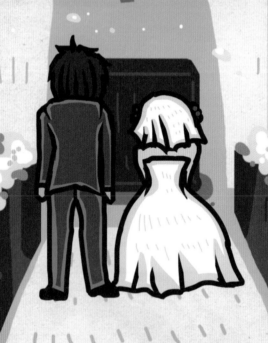

也許……
Perhaps...

他只是因為我寂寞，
而出現的幻想吧……
Perhaps my loneliness gave me hallucinations...

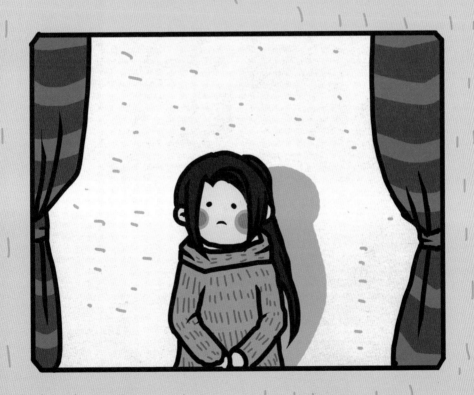

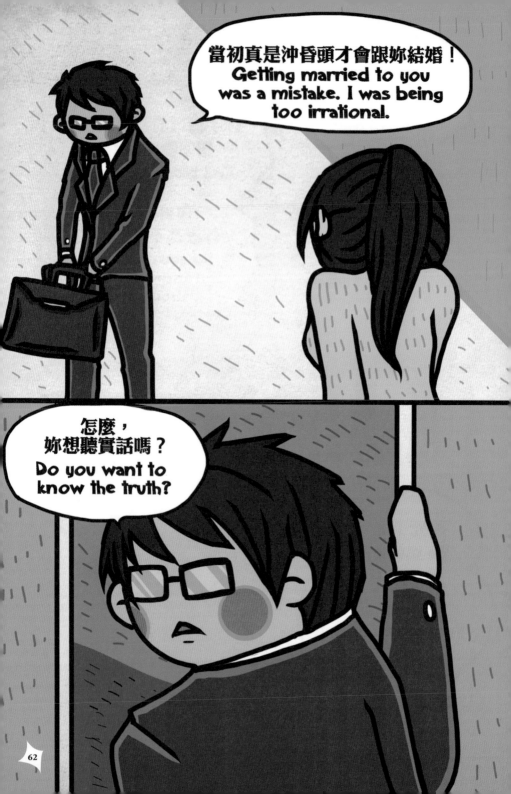

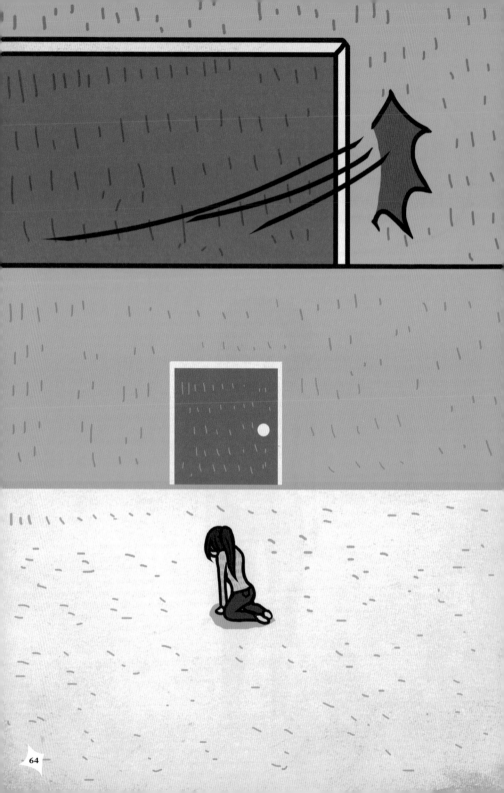

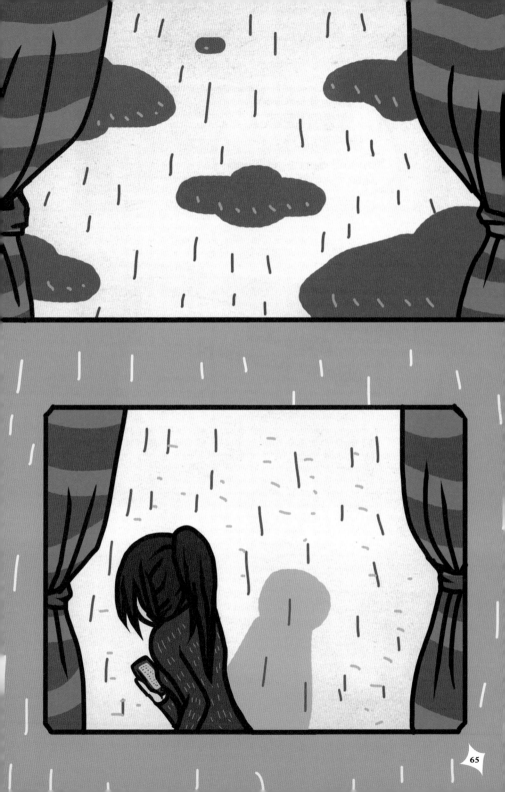

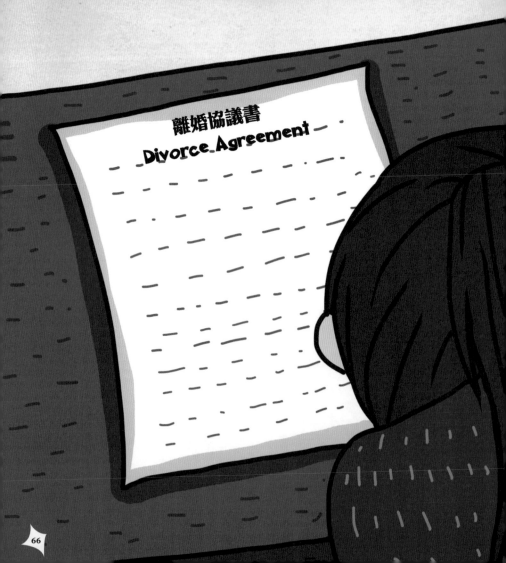

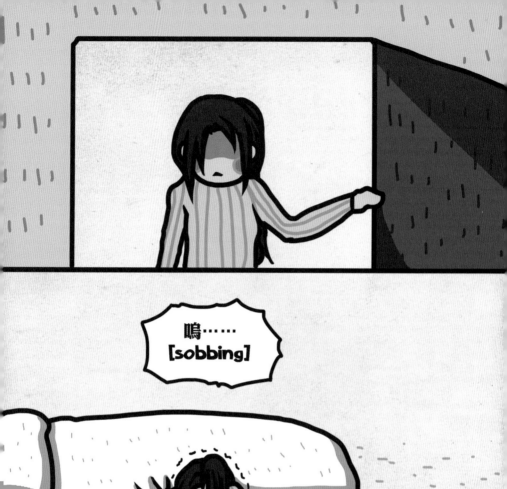

嗚……
[sobbing]

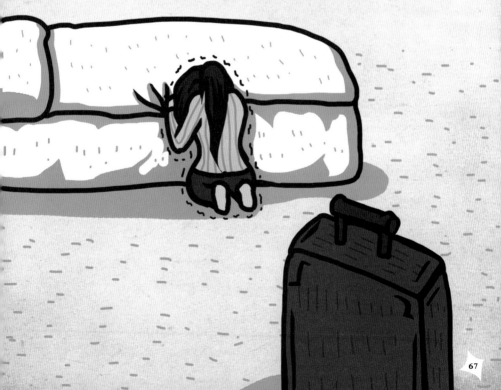

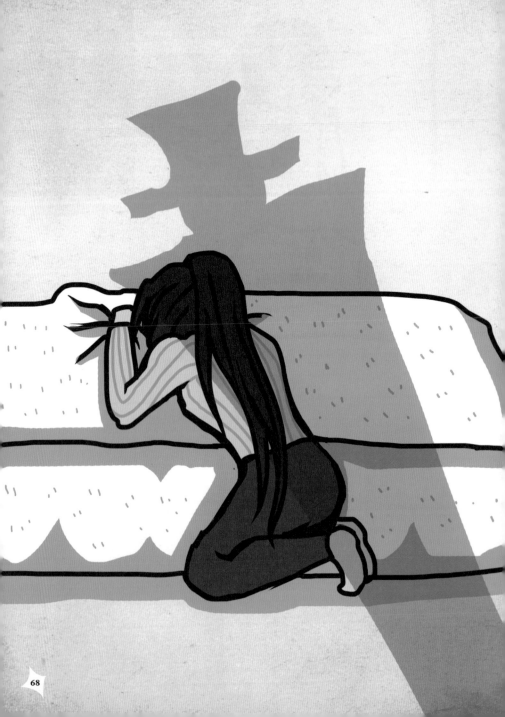

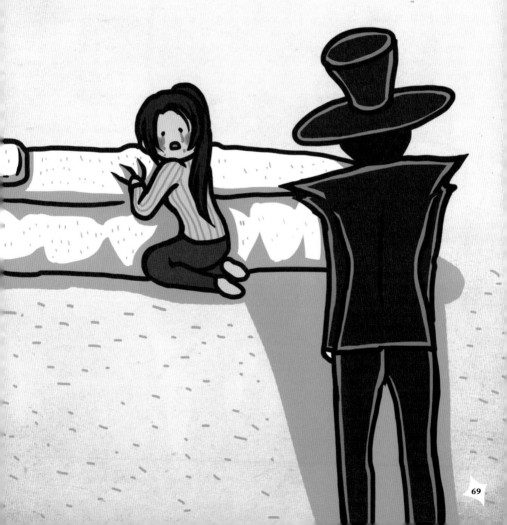

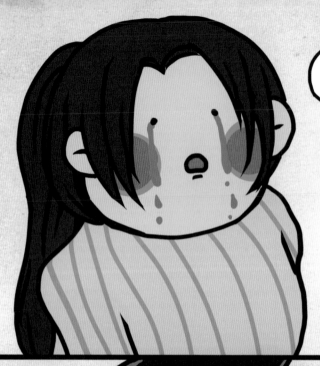

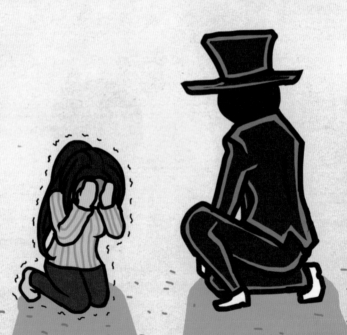

第四章
陪伴

Chapter 4
Accompanied

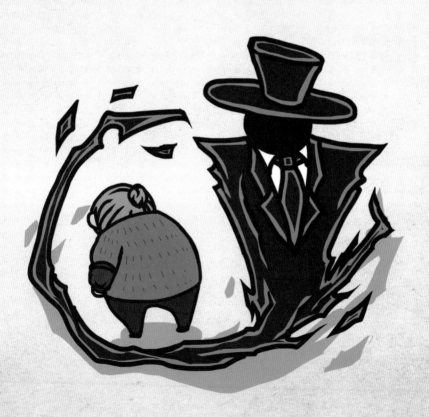

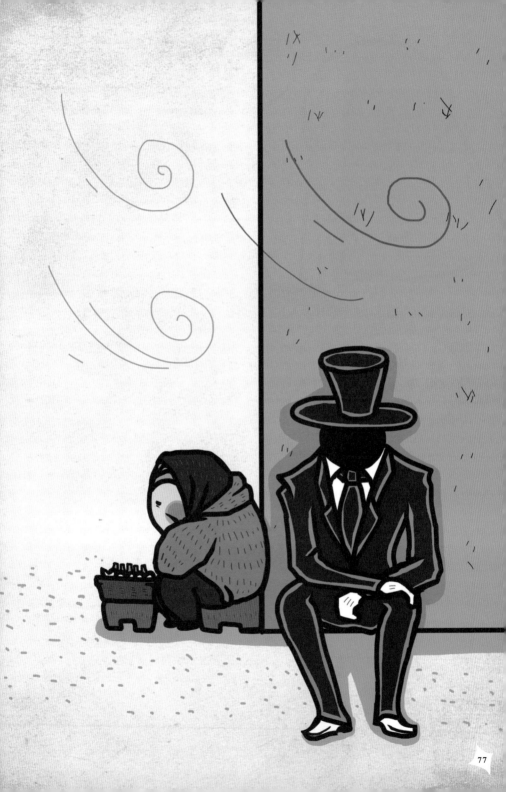

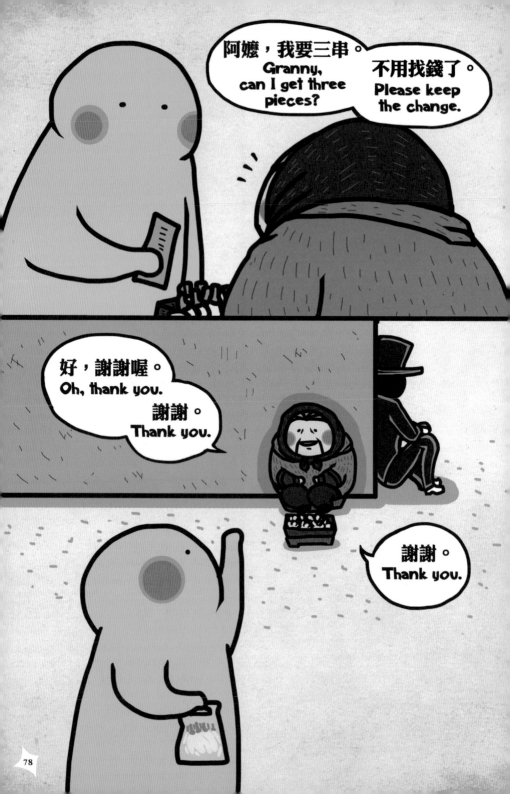

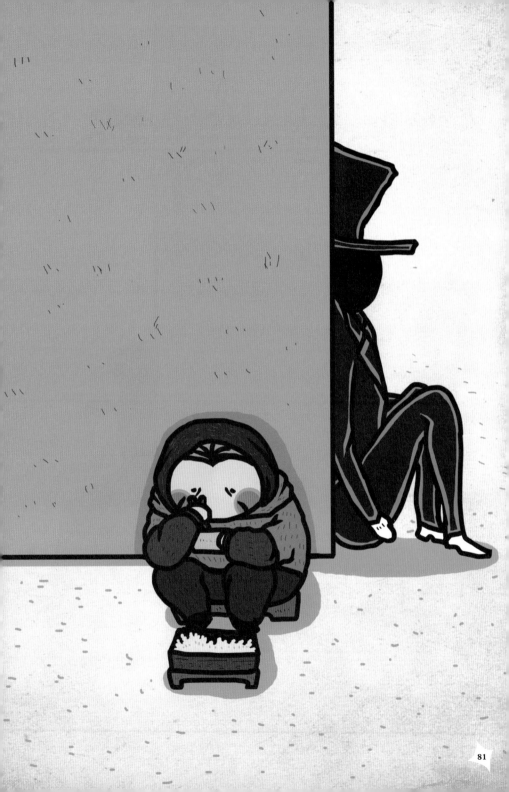

我沒有什麼學歷和專長，年紀也大了。
I don't have much education or skills, and I'm getting old.

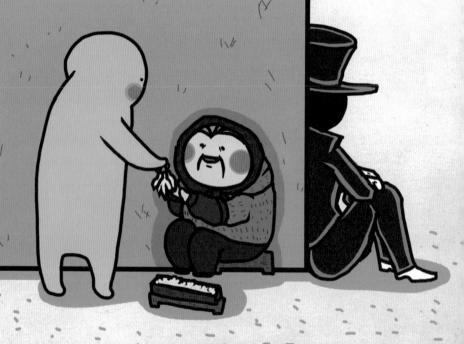

至少我手腳還能動，還可以養活自已。
At least I still have my hands and can make a living.

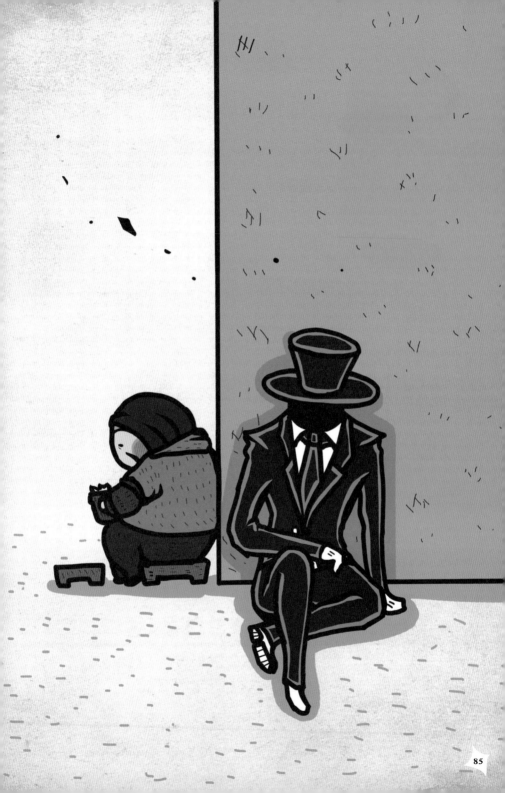

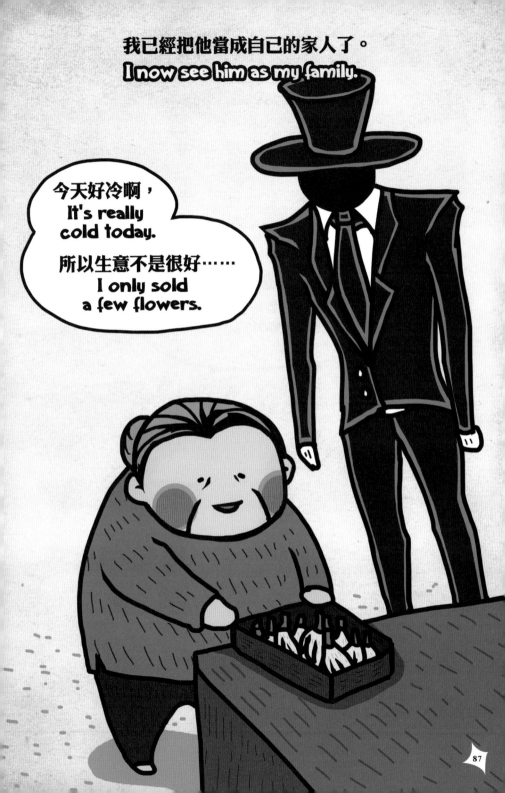

雖然他從來不會回答我。
Although he never responded.

明天會變得更冷呢。
**It will be colder
tomorrow.**

我也碰觸不到他。
And I couldn't touch him.

但是因為有他一直陪著我，
But he always stayed by my side.

明天又要早起了，快睡吧。
We have to get up
early tomorrow.
We should sleep now.

這幾十年來我才覺得自己並不是孤單一人⋯⋯
And all these years,
he made me feel like I was not alone.

第五章
黑西裝的看護

Chapter 5
The caregiver in black suit

我知道我老了。
I knew I've become old.

沒辦法像以前年輕時一樣行動自如。
I could no longer act like a young girl.

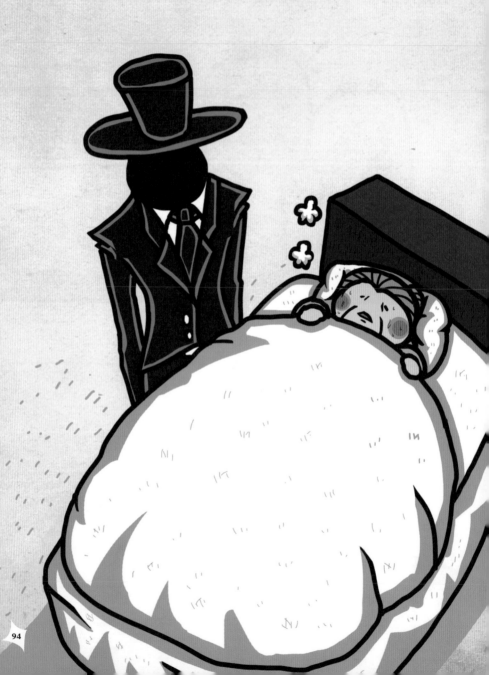

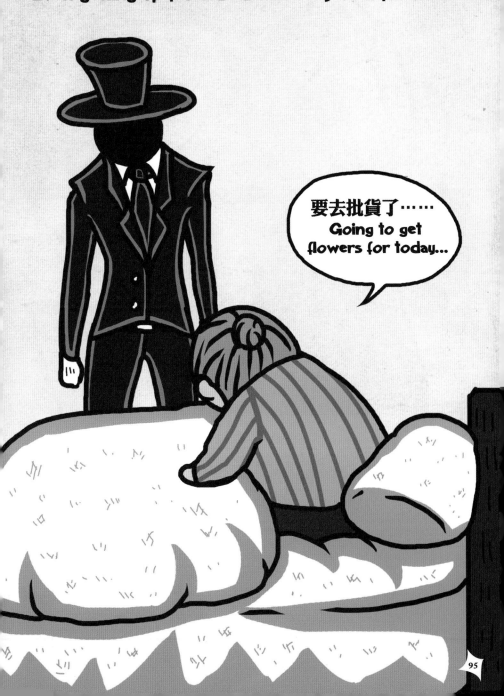

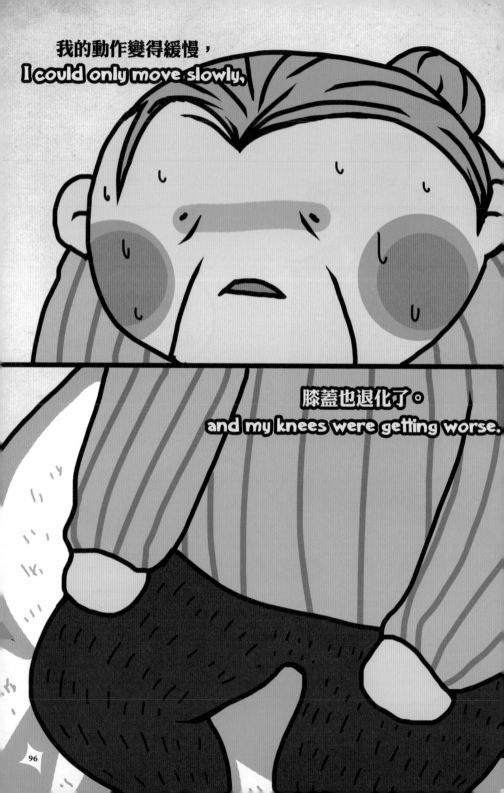

不論我走得多慢，他總是跟在我身後。

**No matter how slowly I walked,
he always stayed behind me.**

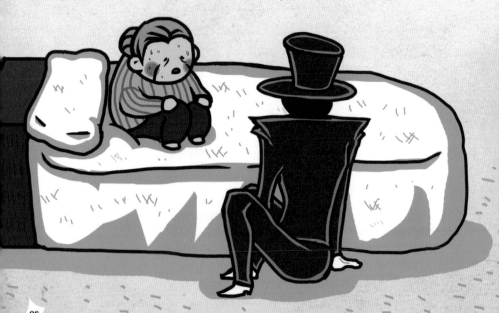

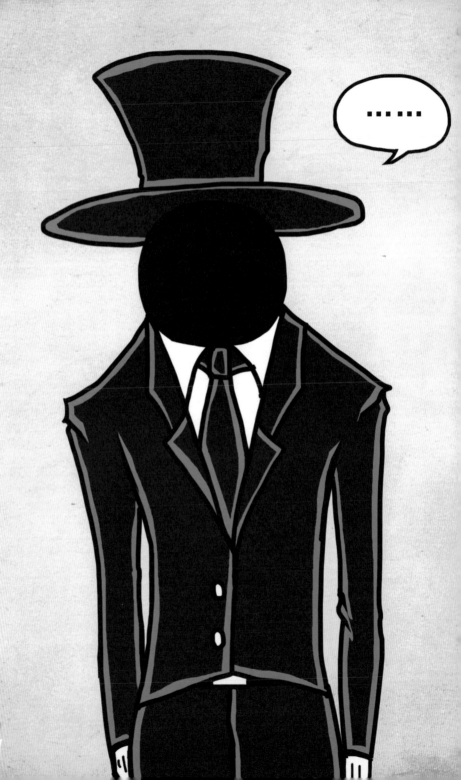

我縮在床上全身發冷。

I huddled up in bed, feeling cold and shivering.

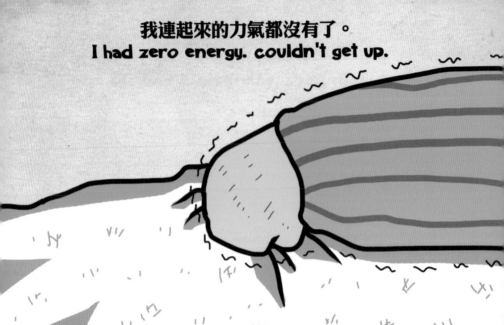

我連起來的力氣都沒有了。
I had zero energy. couldn't get up.

嗚……
Aww.

他今天怎麼不見了？
Where did he go?

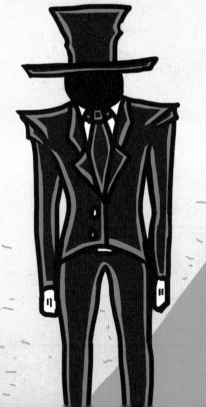

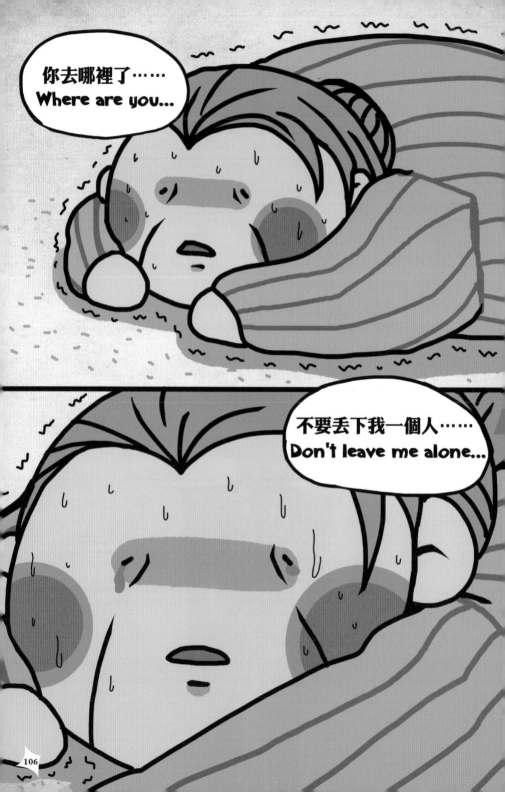

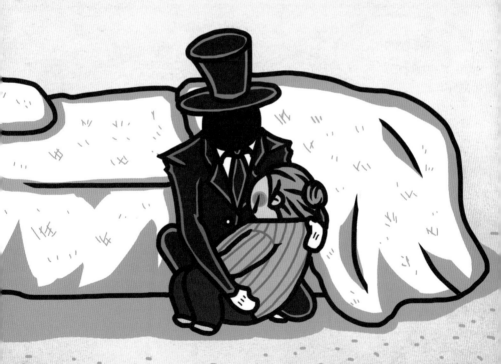

啊……
Ah...

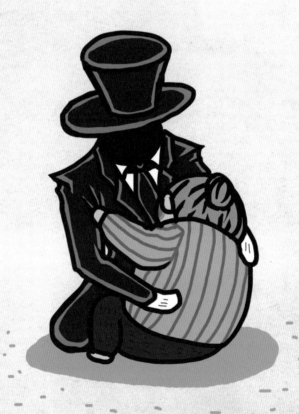

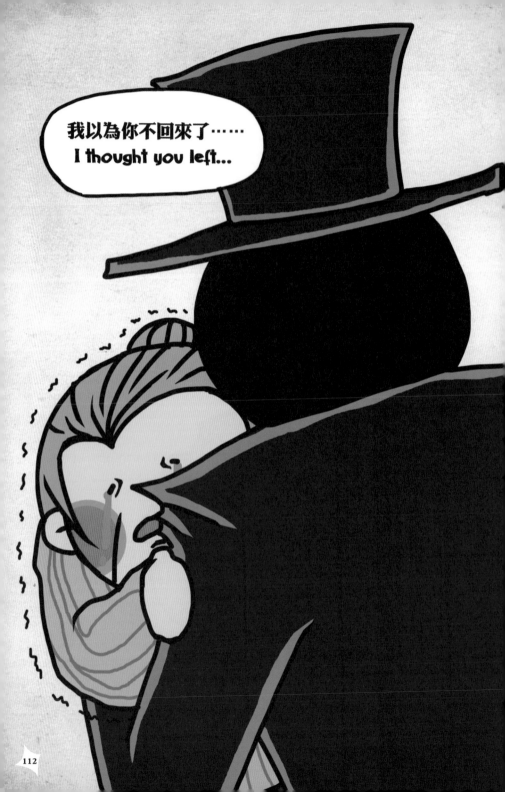

從這天開始，他開始照顧我的生活起居和食衣住行。
**From that day on,
he took care of everything for me.**

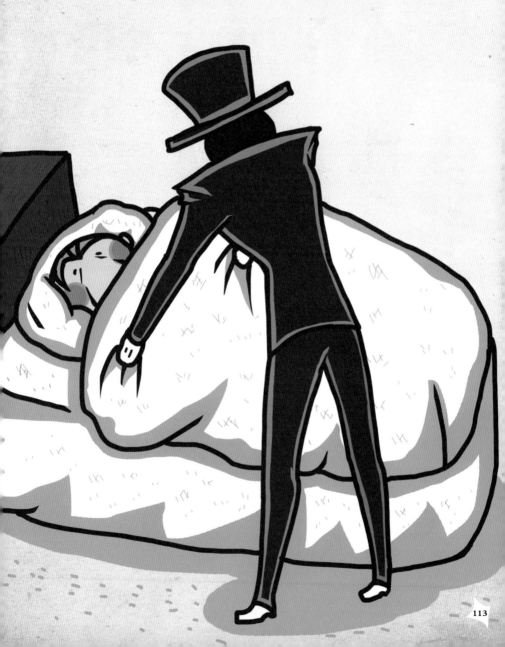

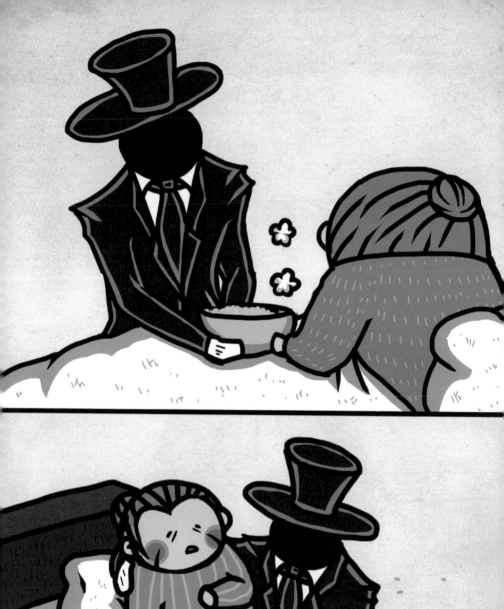
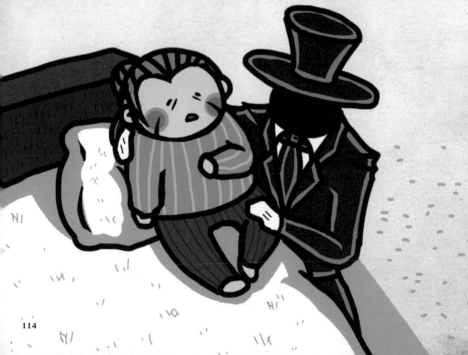

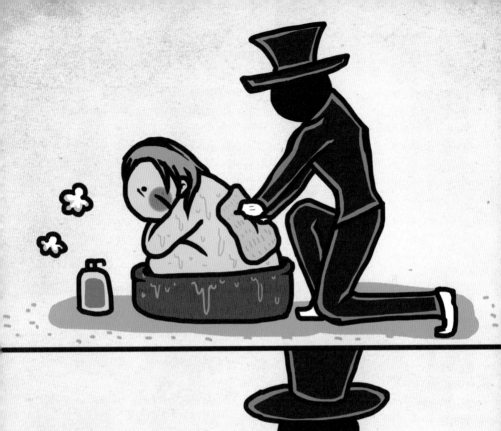

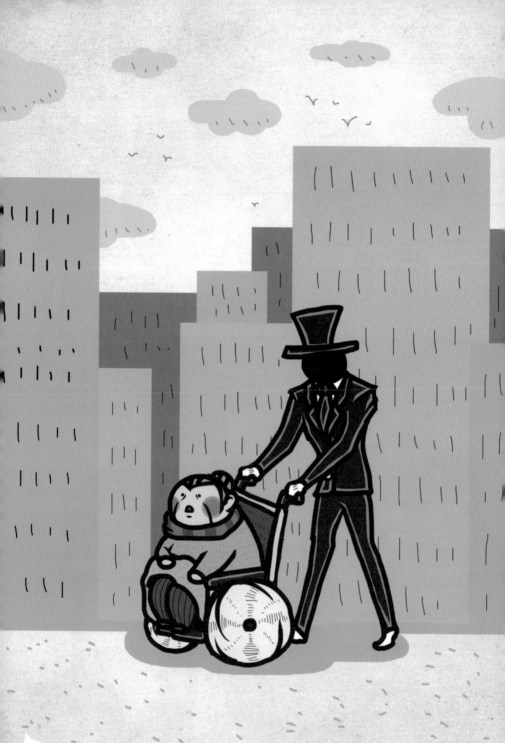

雖然我還是看不見他的臉。
I still couldn't see his face.

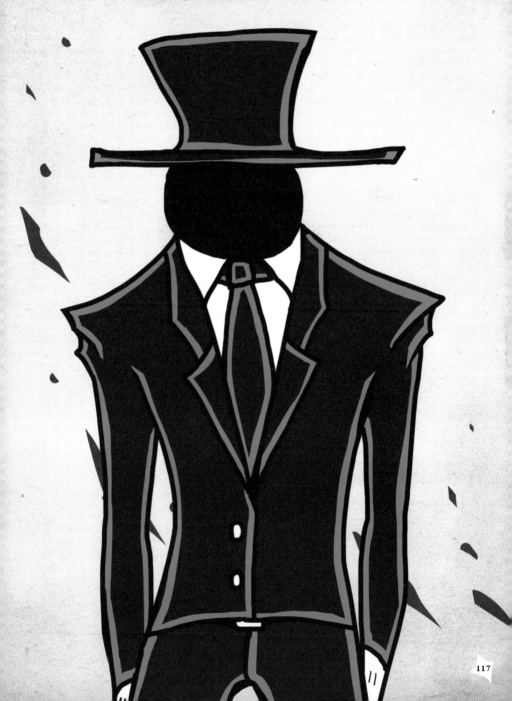

奇怪的是，其他人都看得到他了。
But strangely, everyone could see him.

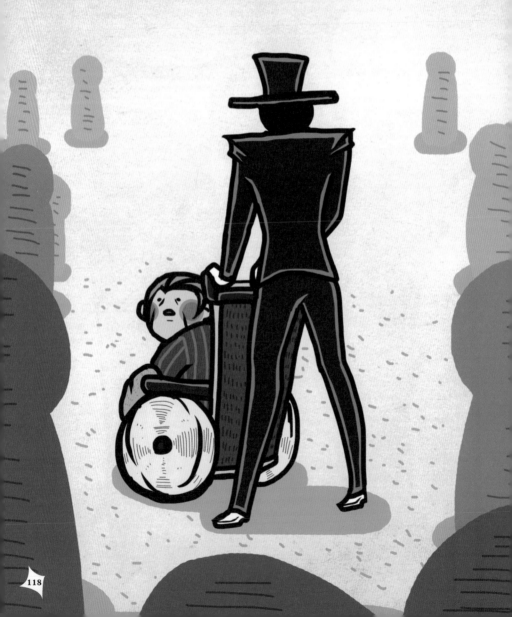

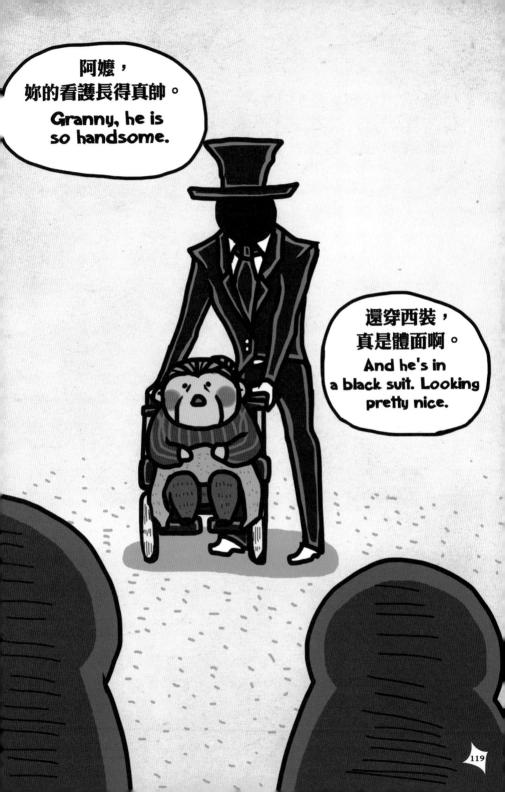

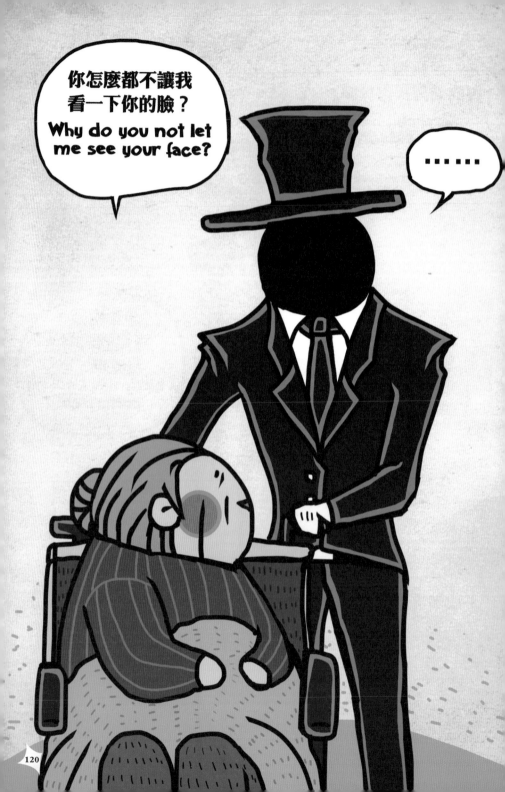

夕陽好漂亮啊。
Beautiful sunset.

我覺得很快樂。
I felt very happy.

這也許是我人生中最幸福的一段日子……
It's probably the happiest moment in my life...

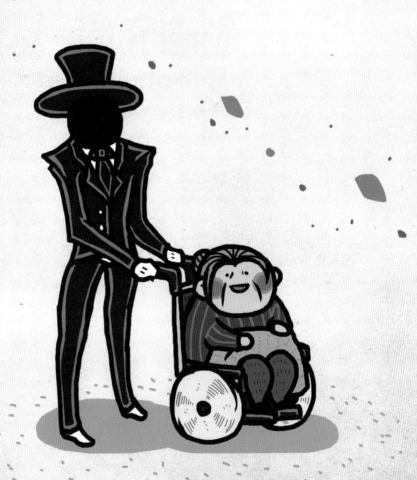

第六章
他的回憶

Chapter 6
His memory

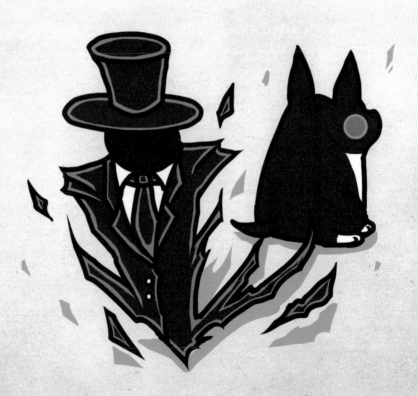

我知道我的生命已經走到了盡頭。
I knew that my life was coming to an end.

只有他一直陪在我身邊。
He's the one who never leaves me.

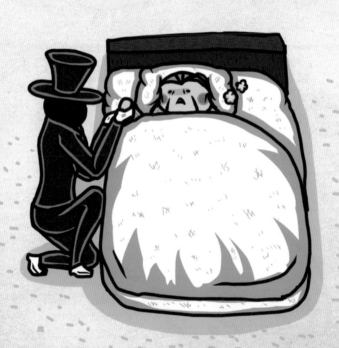

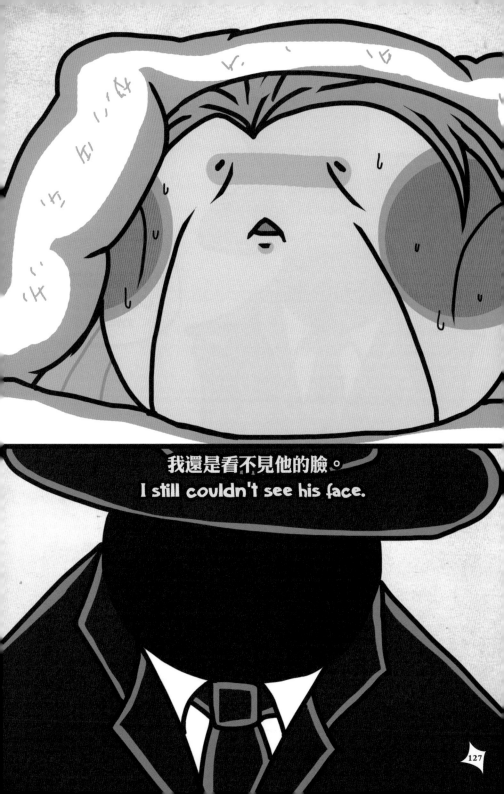

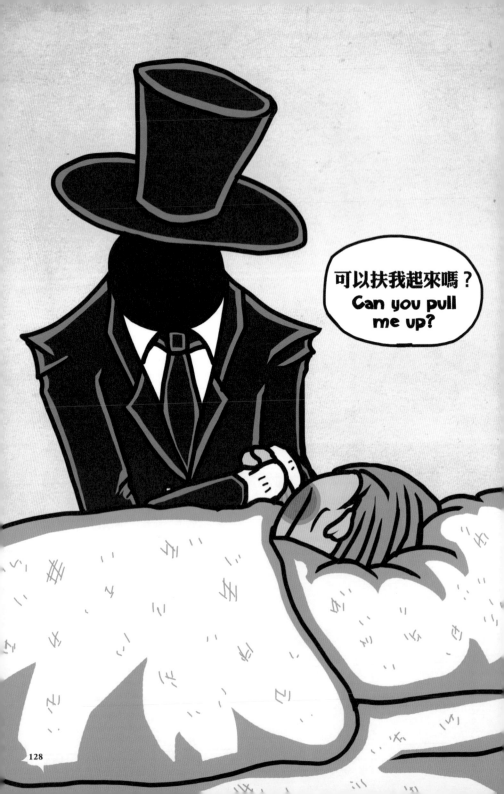

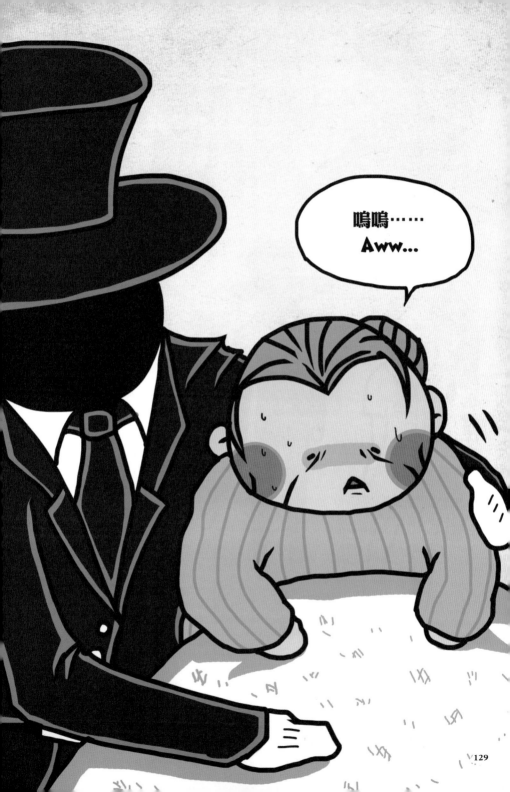

129

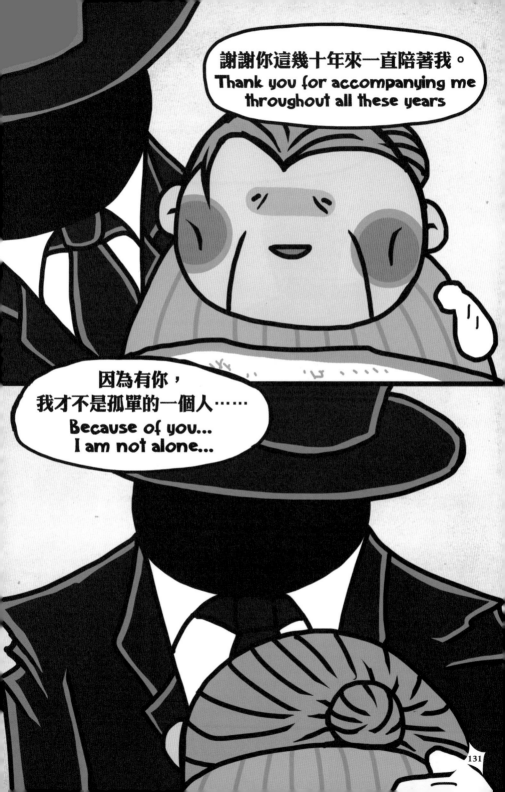

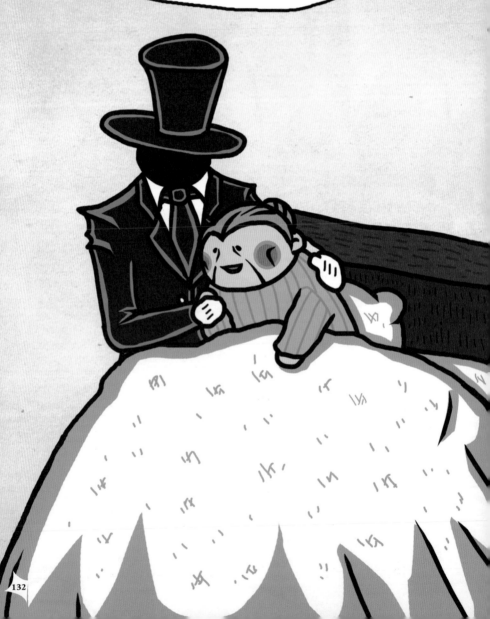

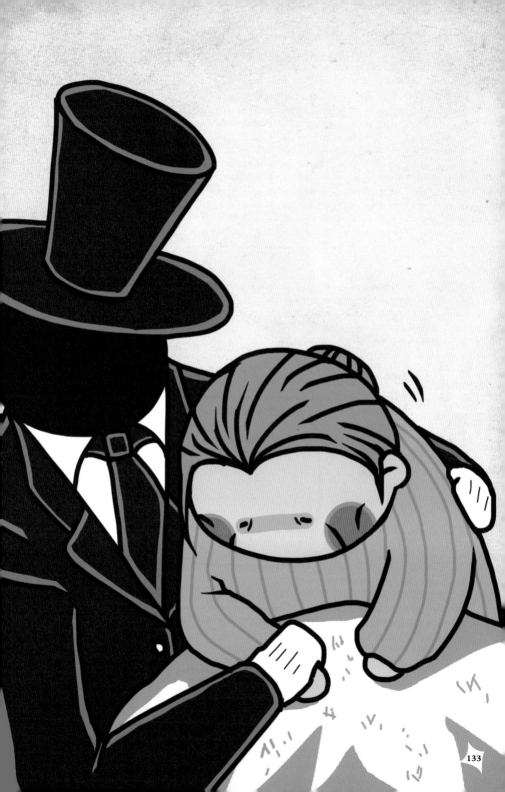

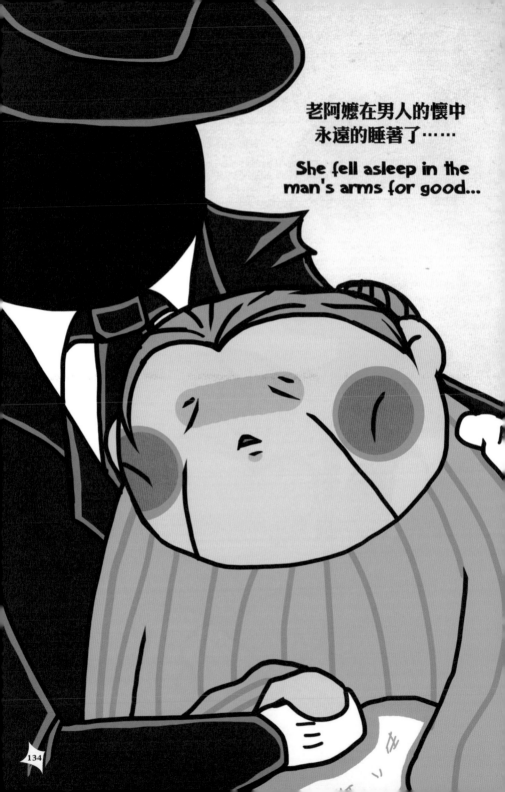

老阿嬤在男人的懷中
永遠的睡著了⋯⋯

She fell asleep in the
man's arms for good...

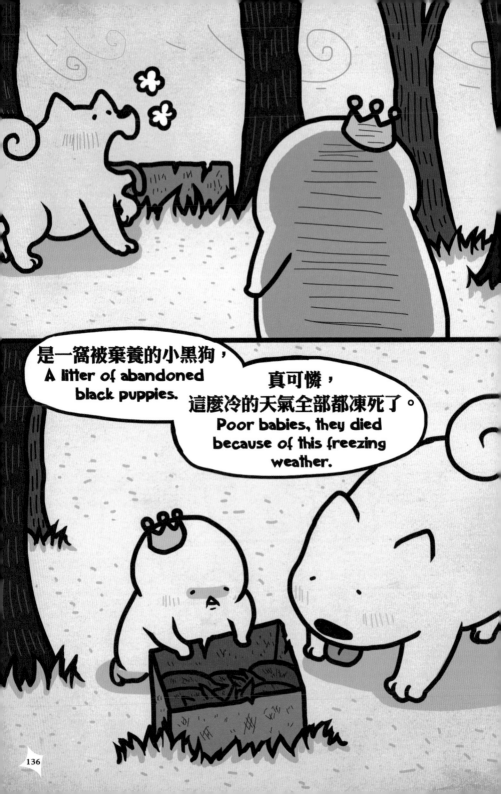

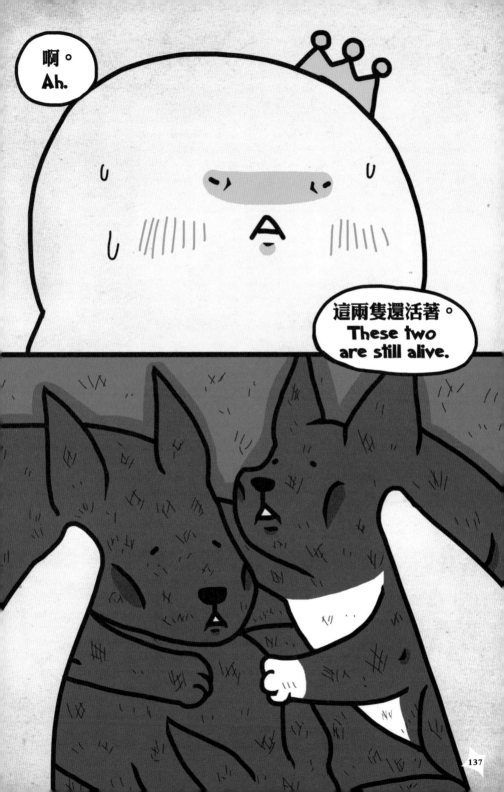

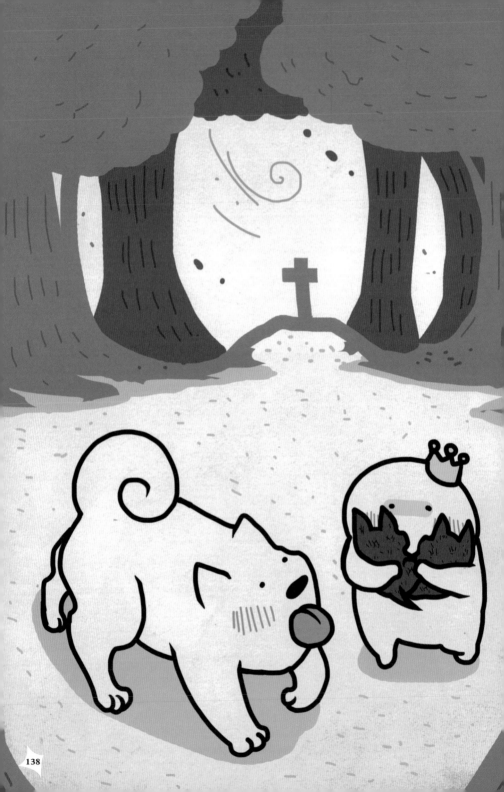

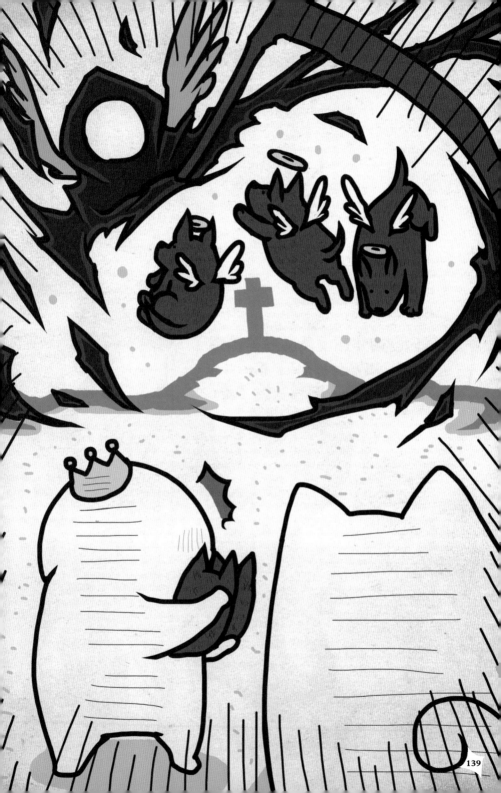

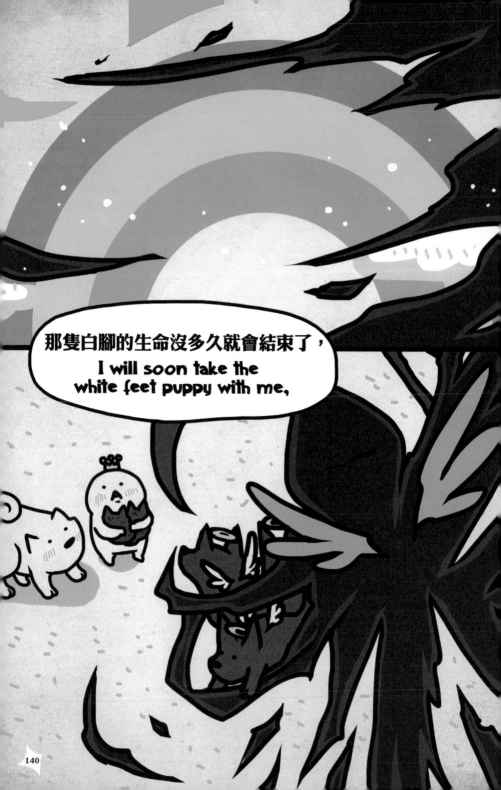

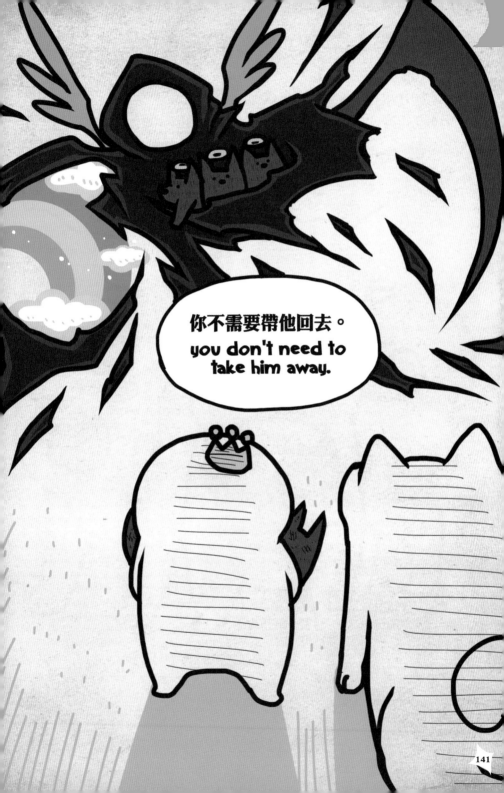

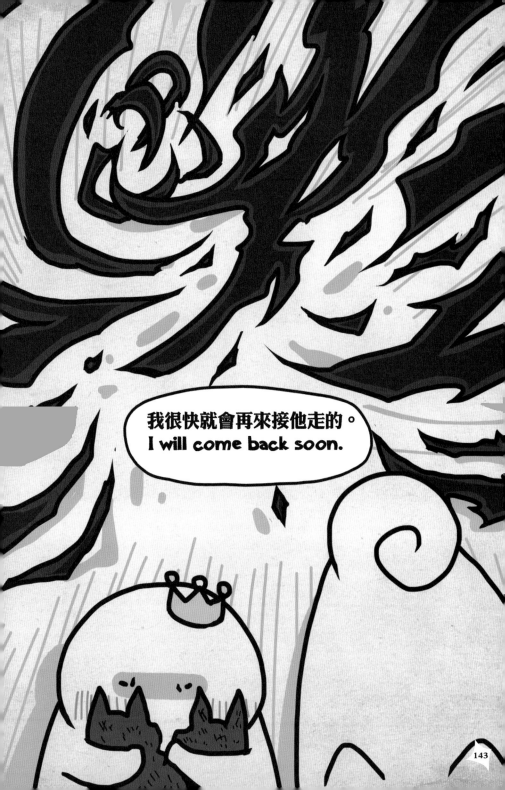

寶總監心願屋
Director Bao's house of wishes

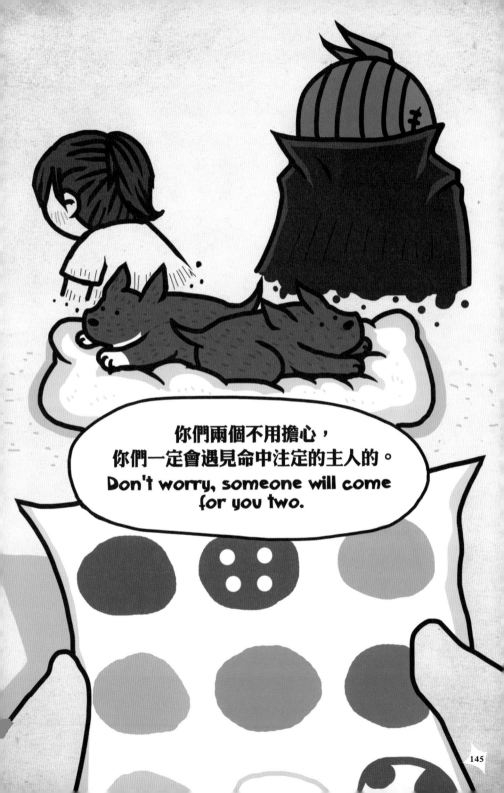

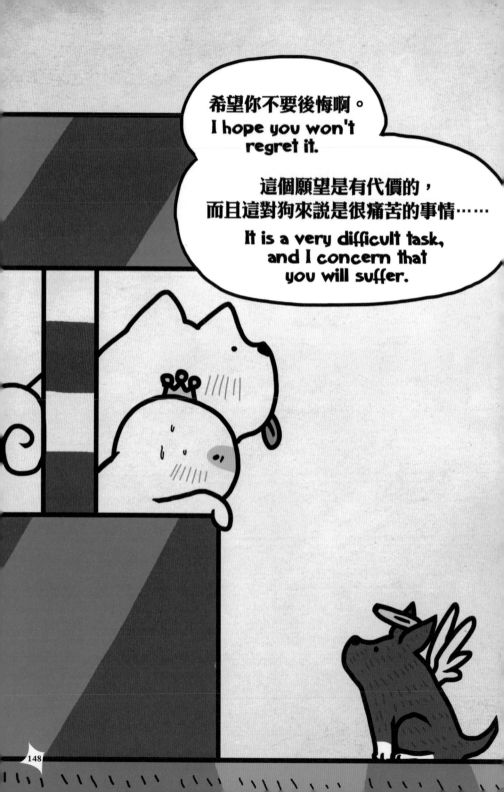

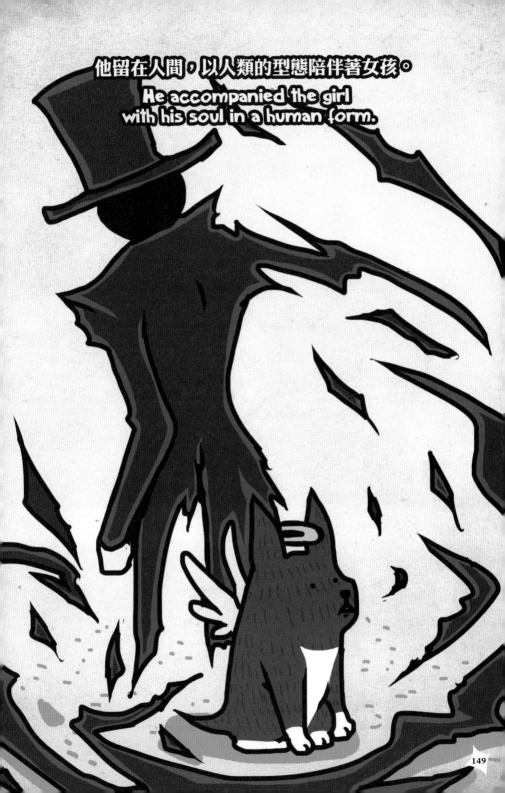

他留在人間，以人類的型態陪伴著女孩。
He accompanied the girl
with his soul in a human form.

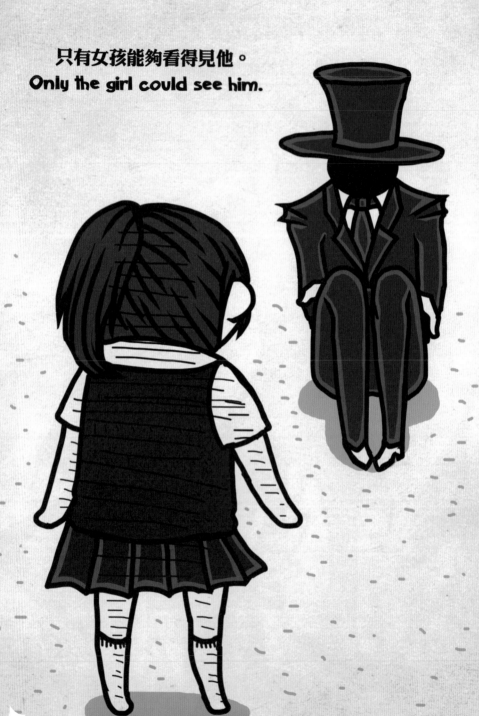

只有女孩能夠看得見他。
Only the girl could see him.

許下這個願望的條件是，
他不能夠說話，女孩也觸碰不到他，看不見他的臉。

He couldn't speak,
the girl couldn't touch him,
and his face couldn't be seen.

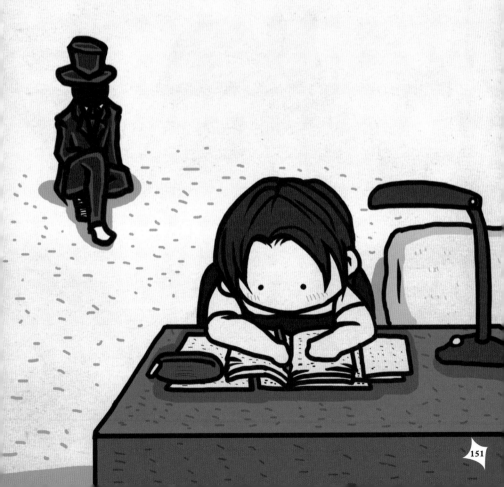

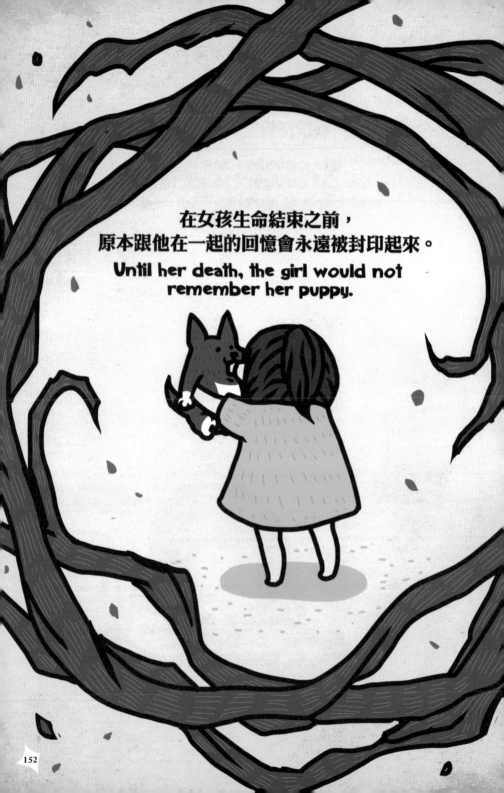

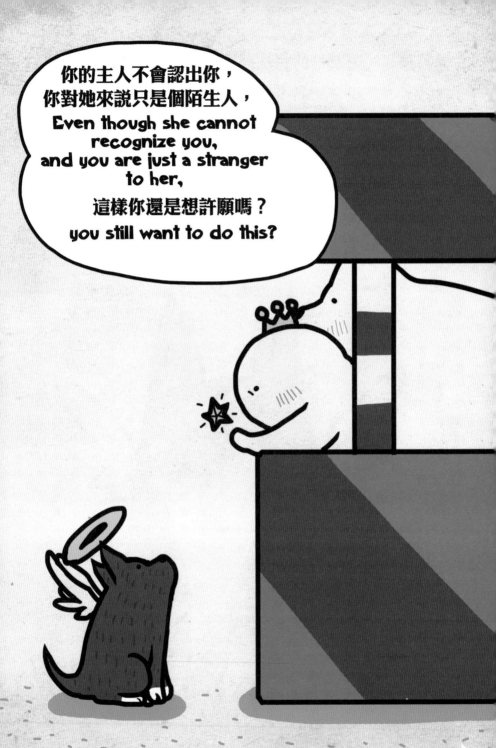

他答應了，因為他的想法很單純，他只想陪在女孩身邊。

He said yes. It was very simple for him
because he just wanted to accompany her.

我要陪主人。
I want to be with her.

寶總監心願屋
Director Bao's house of wishes

隔了好幾十年，他以人類的型態回到了心願屋。
Several decades later, he came back in the black suit.

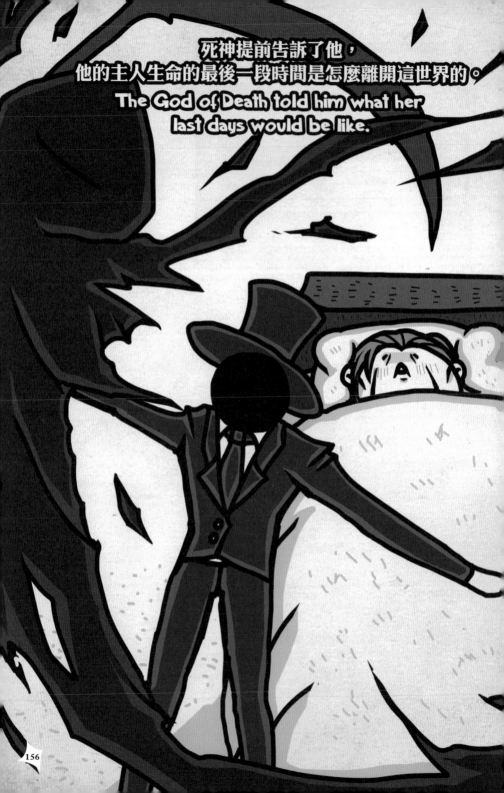

死神提前告訴了他，
他的主人生命的最後一段時間是怎麼離開這世界的。
The God of Death told him what her
last days would be like.

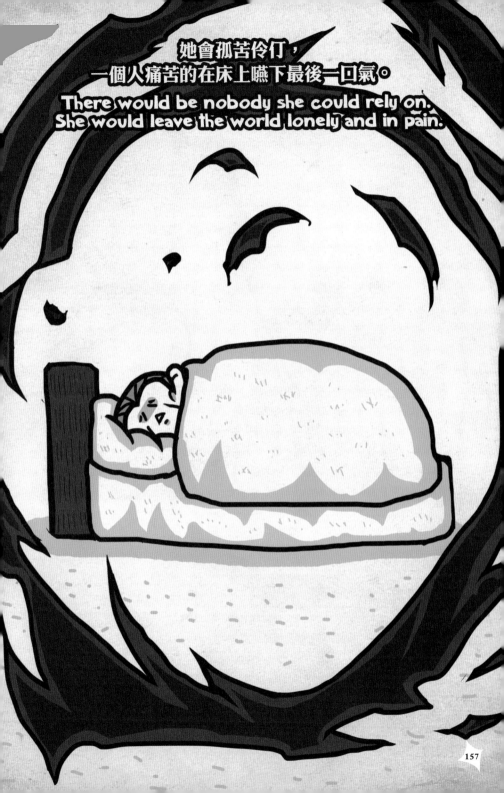

她會孤苦伶仃，
一個人痛苦的在床上嚥下最後一口氣。
There would be nobody she could rely on.
She would leave the world lonely and in pain.

非常的悽慘，像很多獨居老人一樣孤獨的死去。
Miserably, just like many lonely elderly.

他想幫助主人，
於是他再度回到心願屋許下了第二個願望。

**He wanted to help her and that was why
he came back here to make a second wish.**

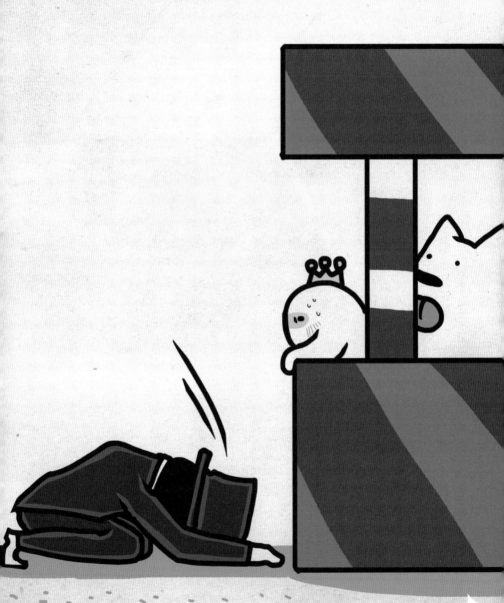

他希望能夠像人類一樣的照顧主人。

He wanted to take care of her
as he had done before.

陪伴主人度過最後在人世的時間。
She would not spend her last days alone.

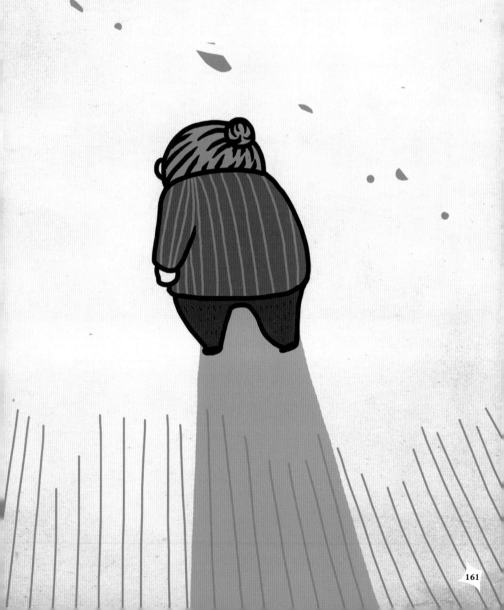

寶總監答應了他，
因為心願屋無法拒絕善良靈魂的任何願望。
Director Bao agreed to help
because anyone with a kind soul deserved it.

而他的第二個願望也實現了……
And his second wish came true...

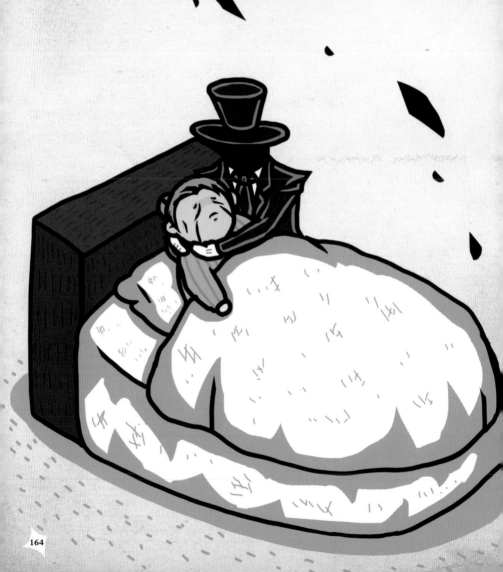

第七章
她與黑色的守護者
Chapter 7
The girl and her black guardian

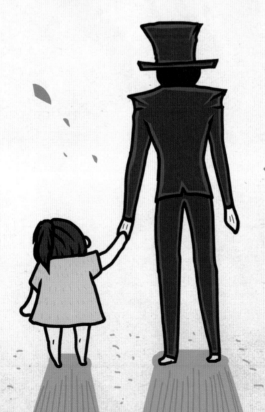

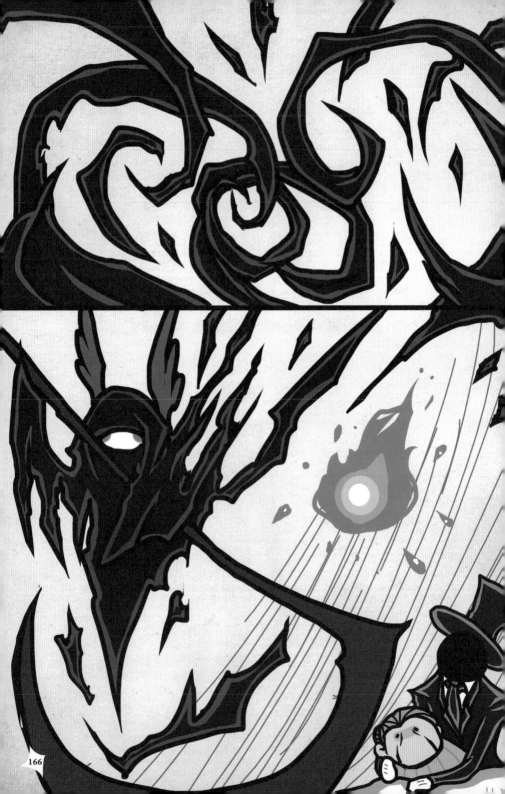

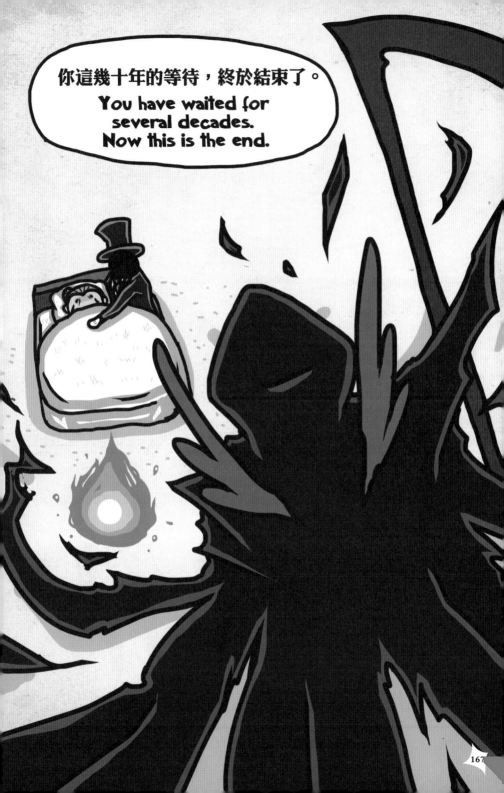

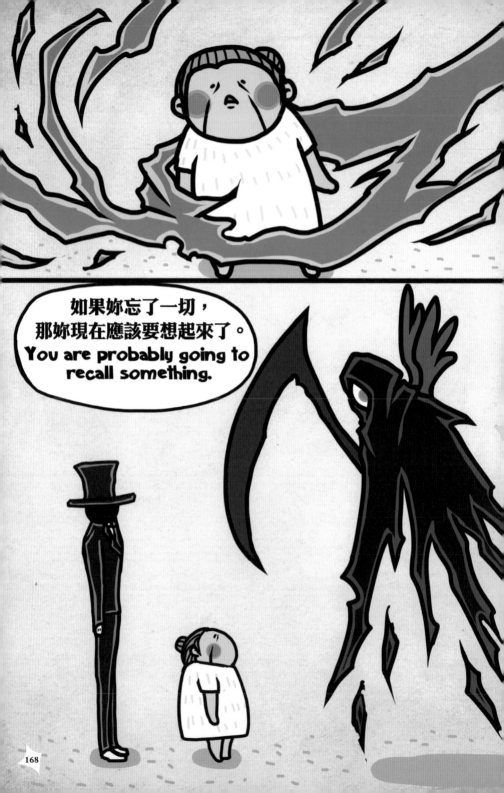

我的媽媽去了很遠的地方，
爸爸好像有另外一個家……
My mom went far far away...
And my dad started
another family...

所以我一直都是一個人……
So I've always been
on my own.

噴，睡過幾次而已
就給我搞這麼大的麻煩……
Crap, I only slept with her
a few times, and now you're
causing me so much trouble.

我不會讓這臭女人
毀掉我的家庭和事業。
I won't let this woman
ruin my family and career.

記著，我只會養妳到高中為止。
Remember, after you graduate
from high school, you are
on your own.

若是社會局的人來，
告訴他們我住在這裡，
妳最好別給我找麻煩！
Tell people from the
government I live here.
You'd better behave!

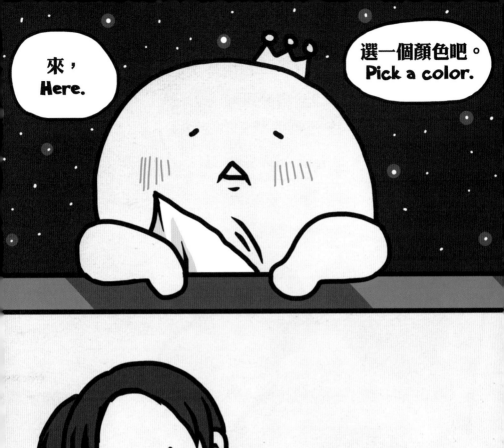

173

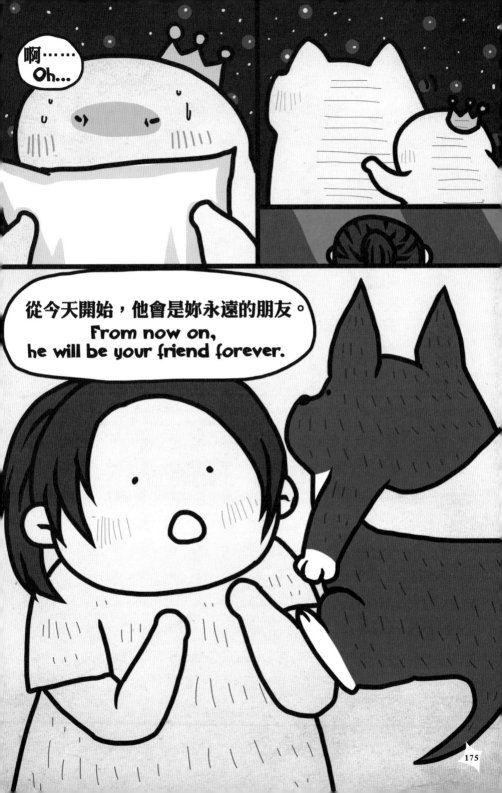

175

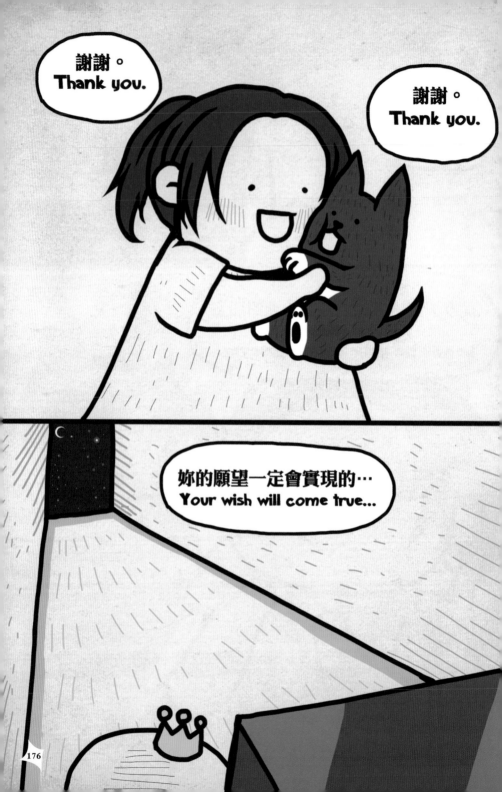

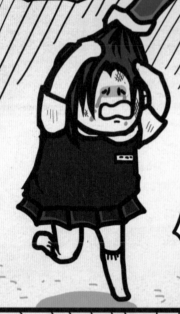

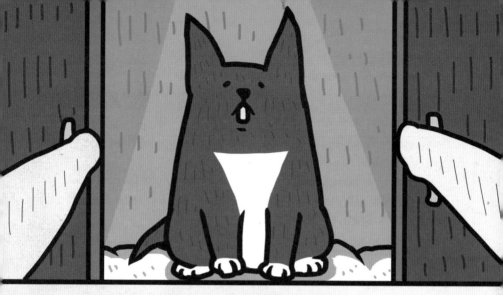

沒關係，
It's okay.
　　沒關係，
　　It's okay.

不要害怕，
Don't be afraid.

我會保護你的……
I will protect you...

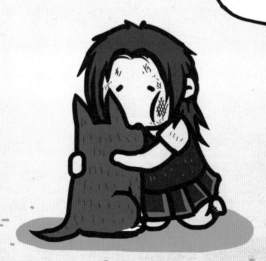

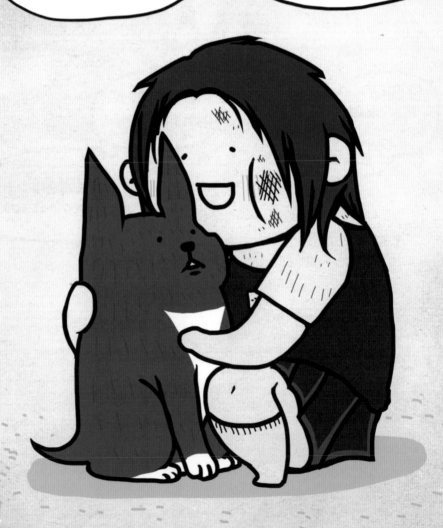

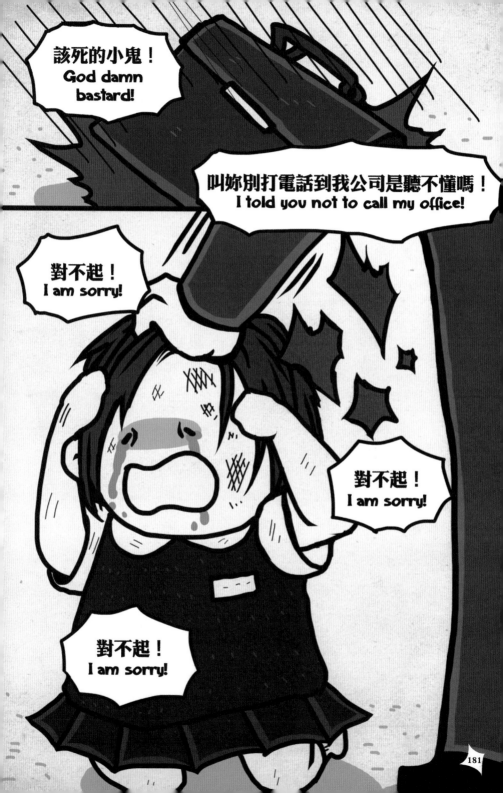

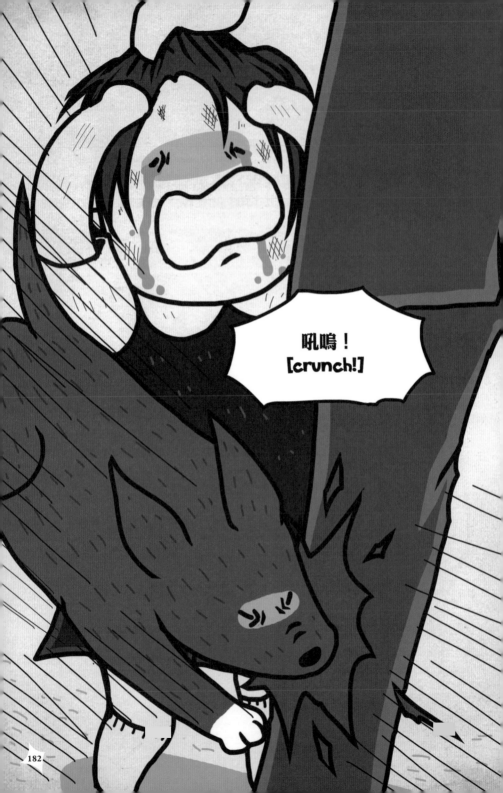

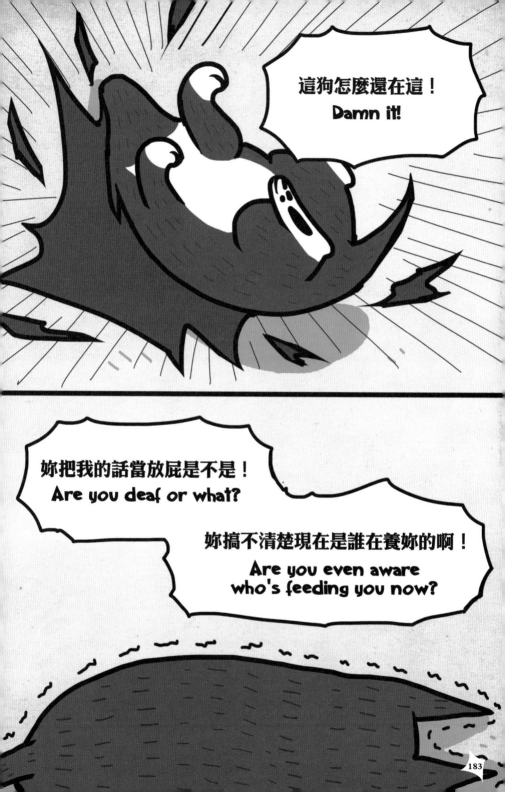

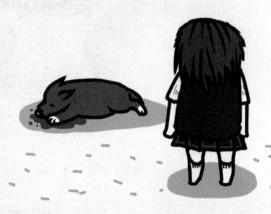

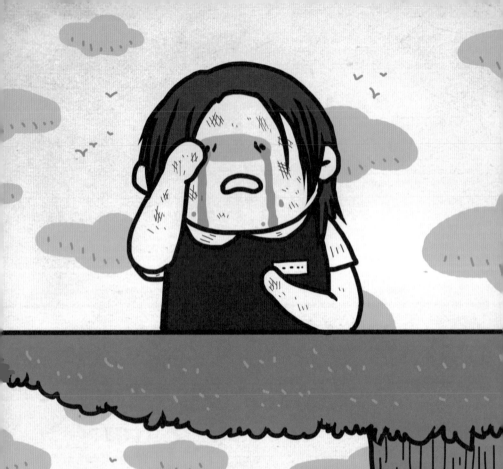
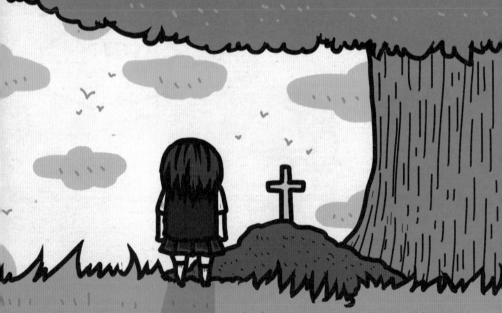

她和小黑狗相處的時間非常短暫，
甚至不到半個月，但是白腳卻永遠記得她對他的好。

They only spent a few days together,
less than two weeks. But White-feet
could never forget her kindness.

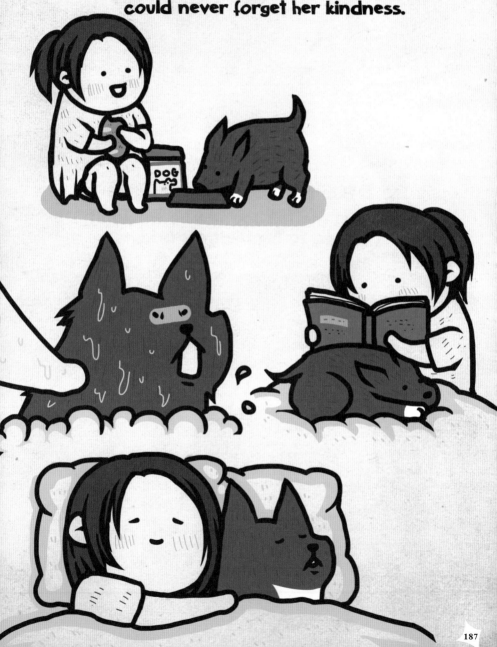

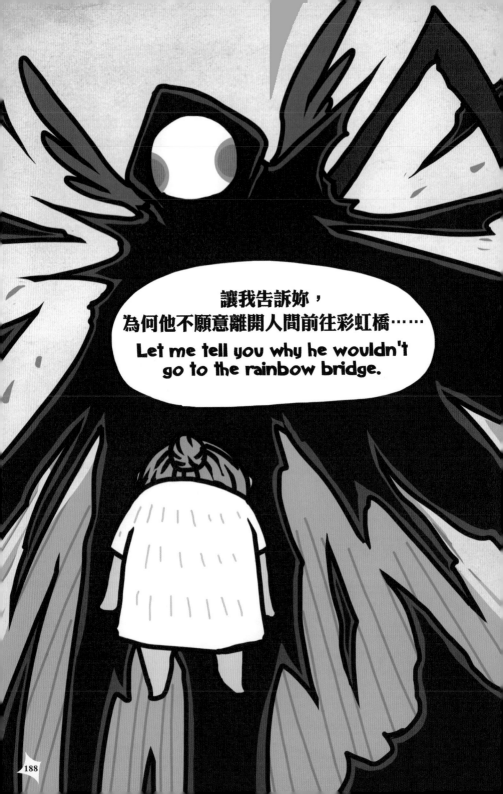

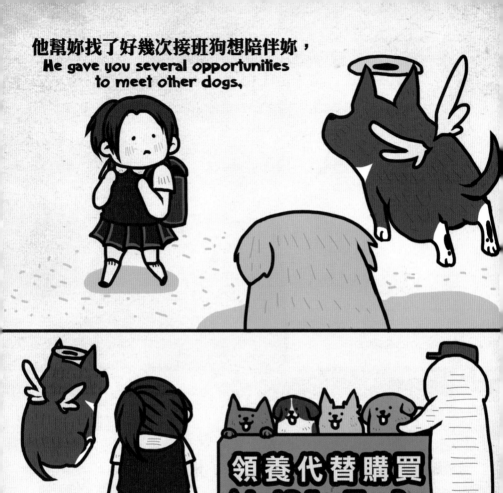

他幫妳找了好幾次接班狗想陪伴妳，
He gave you several opportunities
to meet other dogs,

領養代替購買
Adopt Rather Than Buy

而妳都不願意接受。
but you wouldn't take
any of them with you.

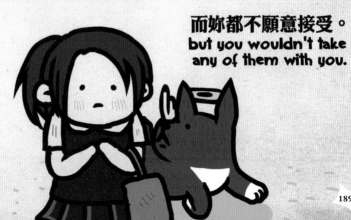

189

他不希望妳獨自孤單一人，
He did not want to leave you alone.

irector Bao's house
of wishes

因此去心願屋
許了兩次願望。

So he went to
Director Bao's house
of wishes twice.

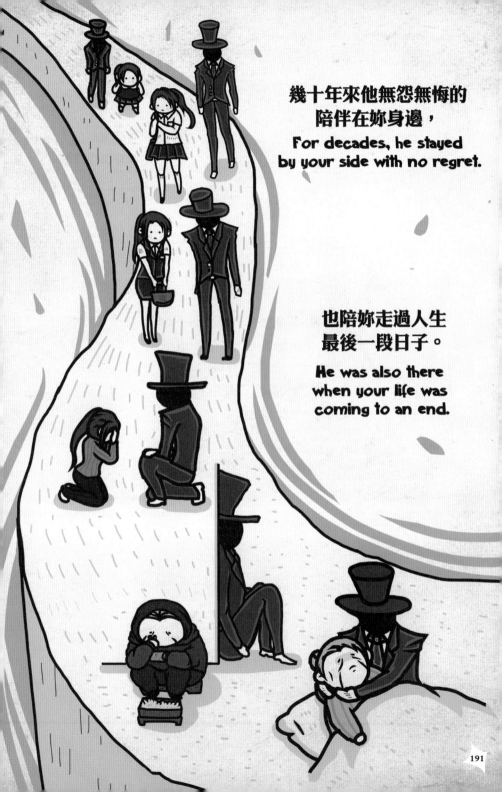

幾十年來他無怨無悔的
陪伴在妳身邊，

For decades, he stayed
by your side with no regret.

也陪妳走過人生
最後一段日子。

He was also there
when your life was
coming to an end.

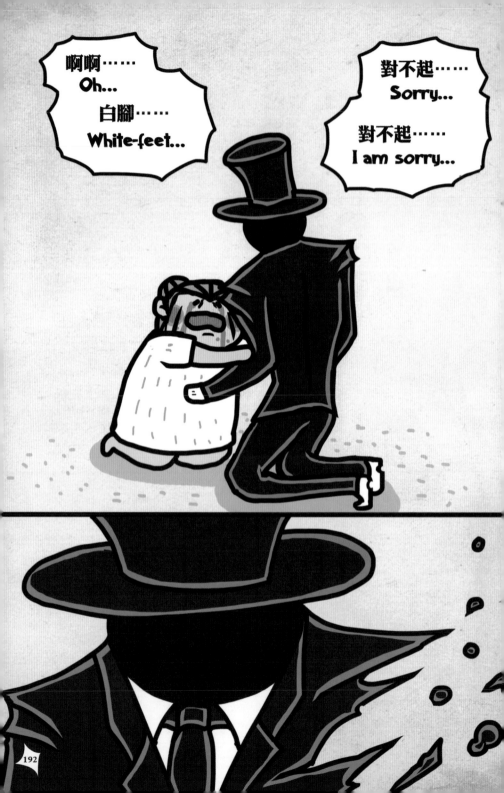

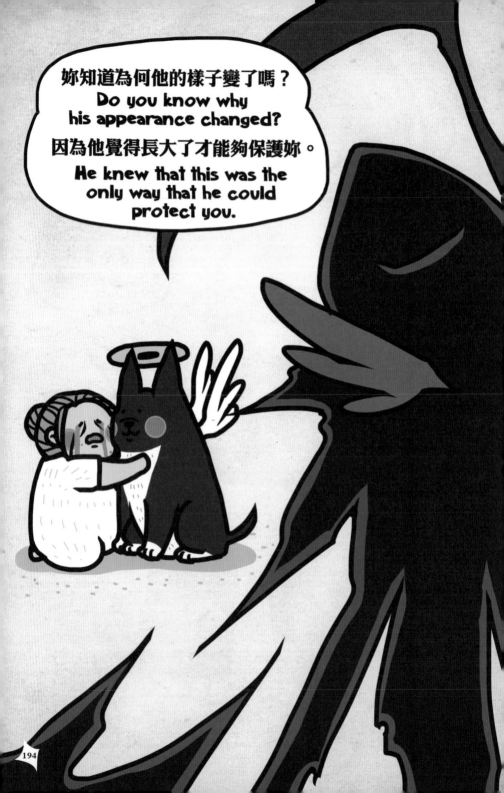

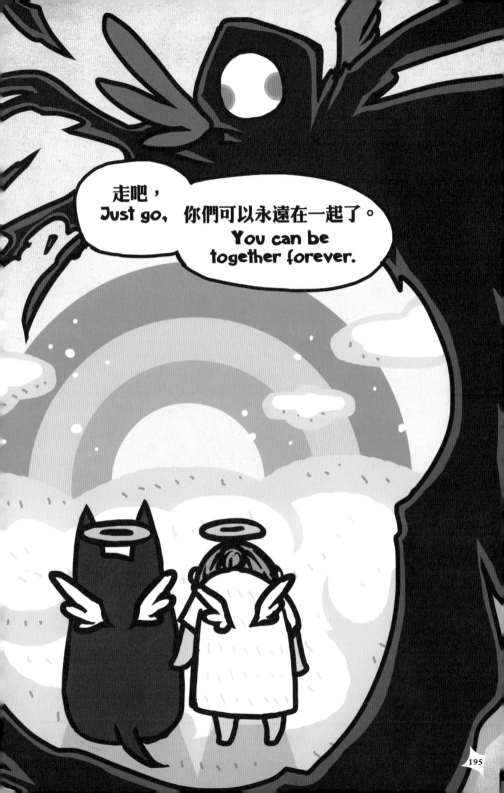

他們有了彼此，再也不孤單了。
They can spend all their time together now,
they are no longer lonely.

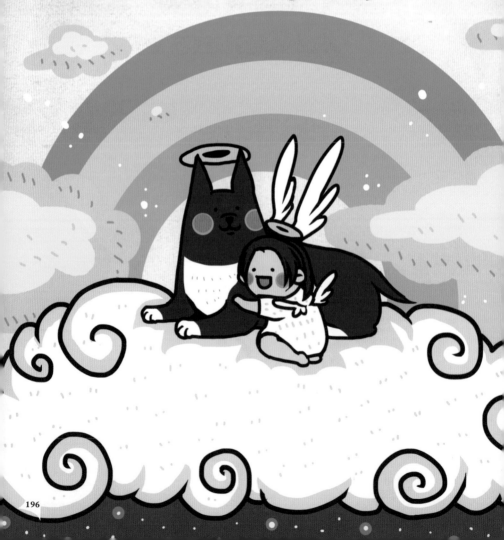

後續
白腳和小黑
Afterword
White-feet and Blacky

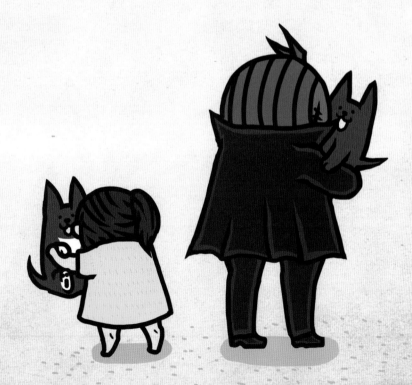

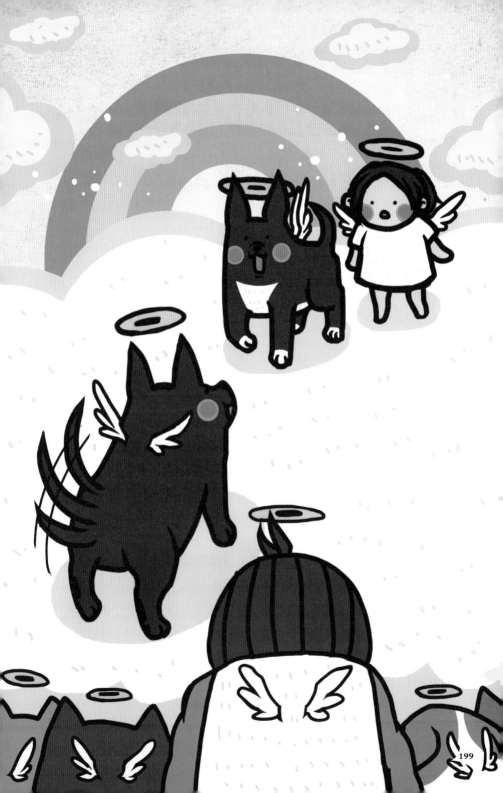

黑狗的真實小故事
A true story of a black dog

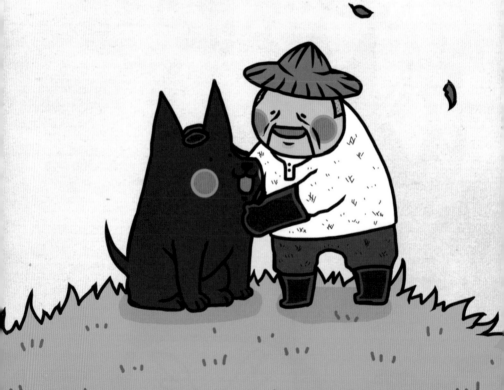

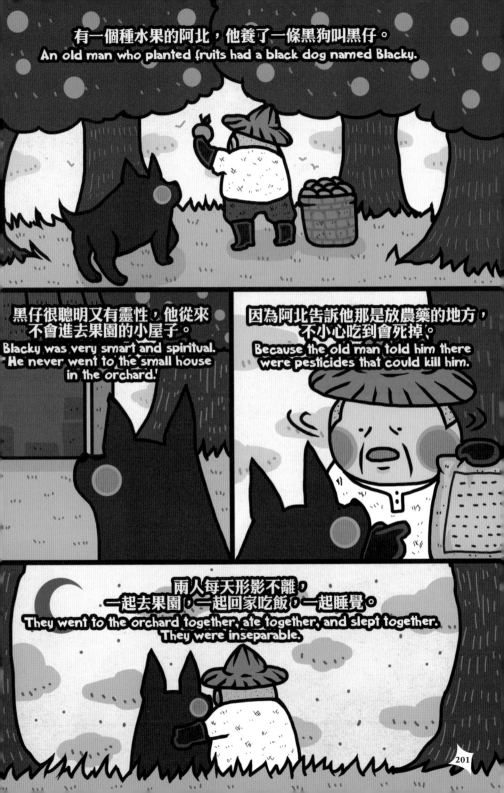

有一個種水果的阿北，他養了一條黑狗叫黑仔。
An old man who planted fruits had a black dog named Blacky.

黑仔很聰明又有靈性，他從來不會進去果園的小屋子。
Blacky was very smart and spiritual. He never went to the small house in the orchard.

因為阿北告訴他那是放農藥的地方，不小心吃到會死掉。
Because the old man told him there were pesticides that could kill him.

兩人每天形影不離，
一起去果園，一起回家吃飯，一起睡覺。
They went to the orchard together, ate together, and slept together. They were inseparable.

有一天，阿北生病死掉了。
One day, the old man got sick and passed away.

黑仔開始不吃不喝，趴在門口望著遠方，
像是在等阿北回家。
Blacky stopped eating.
He kept lying on the ground,
looking into the distance.
It seemed like he was waiting for the old man.

阿北過世之後第三天，黑仔被發現死在果園的小屋子裡面。
而放農藥的袋子被他咬破了一個洞。
Blacky was found dead three days
after the old man passed away due to eating pesticides.

你就是我的全世界，
You mean the world to me.

你離開了，
我的世界也結束了。
My life was finished when you left.

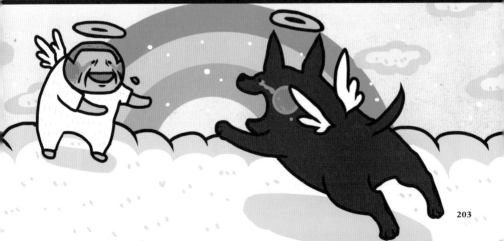

關於黑狗
Black dogs

其實我最愛的是黑色，
當初卻領養到白色啦。

My favorite color for dogs
is actually black,
even though I adopted
a white one.

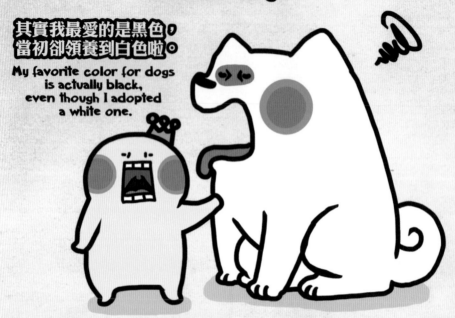

任北覺得
黑色五告讚！
Black dogs rock!

黑狗好聰明
又好可愛！
They are absolutely
smart cuties!

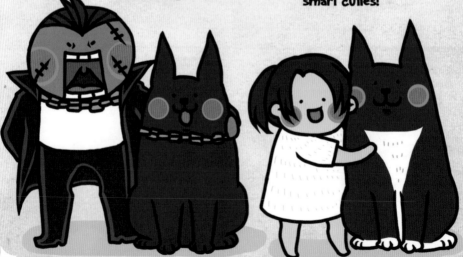

黑狗的特色
Characteristics

養的好
毛色會黑到發亮。
With proper care,
their coat takes on
a shiny black.

牽黑色的大狗
出去很帥很威風。
Huge black dogs are
awesome and imposing.

一般人覺得黑狗很兇，
女生牽黑狗出去散步
壞人不敢靠近你。
In general, people think
black dogs are tough,
so bad guys won't
mess with girls
accompanied
by black dogs.

非常有靈性。
Spiritual.

晚上起床尿尿
容易踩到他。
You may accidentally
step on them
on the way to the
bathroom at night.

拍照很煩因為
都看不到眼睛。
Their eyes are
also black and
invisible on photos.

掉毛時毛的顏色
跟你頭髮一樣。
When they shed,
it's difficult to tell
if it's theirs or yours.

各種黑狗
Types

立耳黑狗
Standing ears

垂耳黑狗
Floppy ears

白腳黑狗
White feet

長毛黑狗
Long haired

四眼黑狗
Dotted eyebrows

台灣黑熊黑狗
Taiwan black bear

隱藏版綜合黑狗
Mixed features

有好幾種特徵
They have many characteristics.

黑狗的困境
Black dog syndrome

老一輩的人覺得
白腳黑狗會帶衰。
The elderly often think
that black dogs with
white feet bring bad luck.

在台灣的收容所裡面，
黑狗的認養率是最低的。
Black dogs in shelters
are less likely to be
adopted in Taiwan.

不知道為何
很多人
不想養黑狗。
I don't know why
many people won't
adopt black dogs.

黑色配金項鍊
整個超唱邱！
A gold collar
on black fur
is awesome!

我超愛黑色，
最喜歡的顏色
是黑色和紅色！
I love black
so much!
Black and red
are my favorite colors.

黑色帶白色
最漂亮了！
Black on white
is beautiful!

她與
黑色的守護者

作者 —— 寶總監

主編 —— 楊淑媚

責任編輯 —— 朱晏瑭

封面繪圖 —— 寶總監

封面設計 —— 張巖

內文排版 —— 張巖

校對 —— 寶總監、朱晏瑭、楊淑媚

行銷企劃 —— 王聖惠

第五編輯部總監 —— 梁芳春

發行人 —— 趙政岷

出版者 —— 時報文化出版企業股份有限公司

　　　　10803 臺北市和平西路 3 段 240 號 7 樓

發行專線 —— （02）23066482

讀者服務專線 —— 0800231705、（02）23047103

讀者服務傳真 —— （02）23046858

郵撥 —— 19344724 時報文化出版公司

信箱 —— 臺北郵政 7999 信箱

時報悅讀網 —— www.readingtimes.com.tw

電子郵件信箱 —— yoho@readingtimes.com.tw

法律顧問　理律法律事務所　陳長文律師、李念祖律師

印刷　詠豐印刷有限公司

初版一刷　2018 年 6 月 22 日

初版二刷　2018 年 7 月 24 日

定價　新臺幣 320 元

（缺頁或破損的書，請寄回更換）

時報文化出版公司成立於 1975 年，並於 1999 年股票上櫃公開發行，
於 2008 年脫離中時集團非屬旺中，以「尊重智慧與創意的文化事業」為信念。

她與黑色的守護者 / 寶總監作. -- 初版. -- 臺北市：時報文化，
2018.06　面；　公分　ISBN 978-957-13-7425-3（平裝）

1. 漫畫

947.41　　　　　　　　　　　　　　107007993

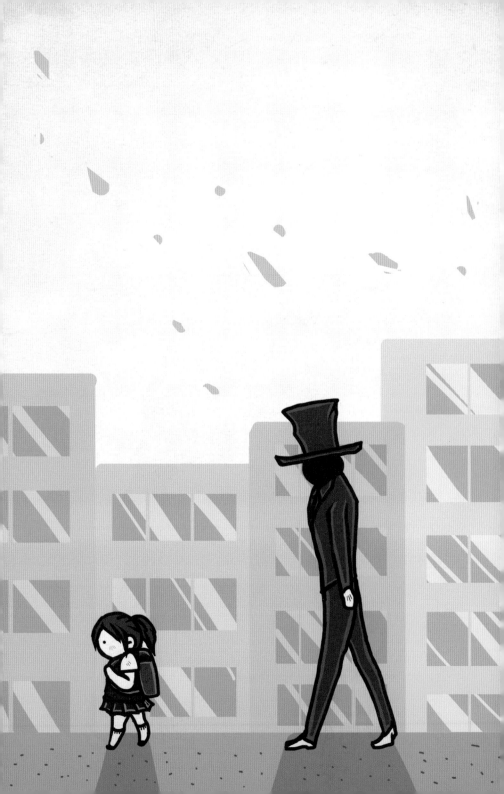

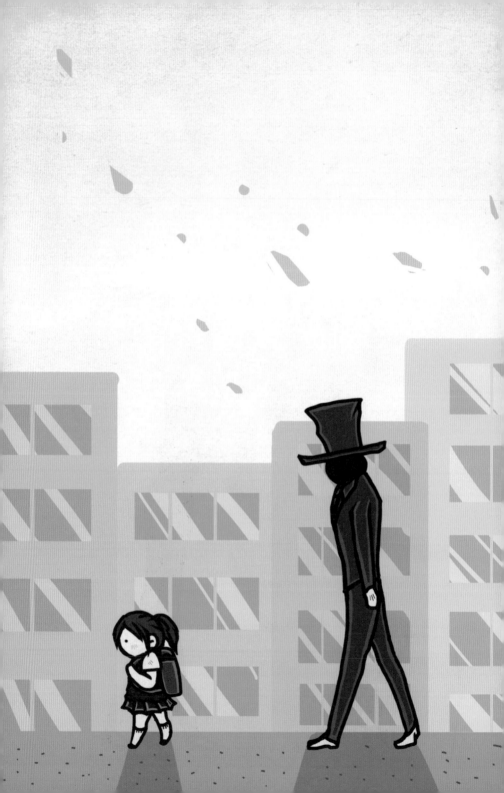